THE
ARTS MATTER

*A series of lectures organised by the
Royal Society for the encouragement of Arts,
Manufactures and Commerce*

RSA
Gower

Illustrations provided by Richard Wentworth. *False Ceiling* and *Tract (from Boost to Wham)* are reproduced by courtesy of Lisson Gallery.

Published by
Gower Publishing Limited
Gower House
Croft Road
Aldershot
Hampshire GU11 3HR
England

Gower
Old Post Road
Brookfield
Vermont 05036
USA

The authors of these lectures have asserted their rights under the Copyright, Designs and Patents Act 1988 to be identified as the authors of this work.

British Library Cataloguing in Publication Data
A catalogue record for this book is available from the British Library

ISBN 0-566-07977-1

The Arts Matter lecture series is supported by the Arts Council of England and the Calouste Gulbenkian Foundation, and sponsored by Crayola®. The British American Arts Association is gratefully acknowledged for their help in organising Chuck Mike's lecture.

Designed by Bob Vickers and printed in Great Britain by Biddles Ltd, Guildford.

THE
ARTS MATTER

The RSA and Its Programme

The Royal Society for the encouragement of Arts, Manufactures and Commerce (RSA) was founded in 1754 with a mission to 'embolden enterprise, to enlarge science, to refine art, to improve our manufactures and to extend our commerce'. Believing that a thriving economy was the determining factor in the development of a civilised society, the RSA's founding Fellows sought to encourage innovation, the acquisition of new skills and the creation of new markets.

The RSA today uses its independence and the resources of its international Fellowship to stimulate debate, develop ideas and encourage action in its main fields of interest: business and industry, design and technology, education, the arts and the environment. The RSA Fellowship (now numbering nearly 21,000 in this country and abroad) is drawn from almost every vocation and provides a resource of expertise and practical experience on which the Society can call.

The RSA is good at forming partnerships, at working with others to increase the pressure for change. The Society provides a forum for discussion within which ideas may be shaped and action stimulated. Often the process starts with a lecture, seminar or conference, then may follow active promotion through a project, campaign or award scheme.

Current projects include Redefining Work, PROJECT2001, the National Advisory Council for Careers and Educational Guidance, the RSA Student Design Awards, and The Arts Matter programme.

For more information please write to: The Director, RSA, 8 John Adam Street, London WC2N 6EZ or telephone 0171 930 5115.

CONTENTS

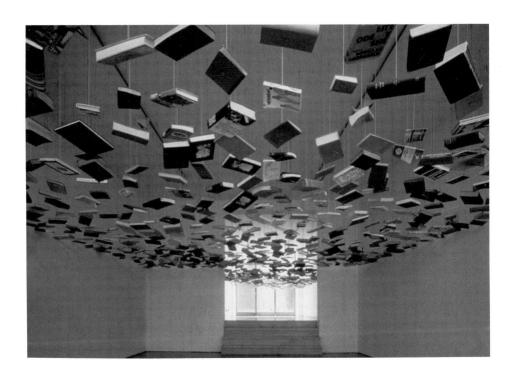

False Ceiling by Richard Wentworth, 1995

THE GOVERNMENT'S VISION FOR THE ARTS

MARK FISHER, MP

Minister for The Arts

'The arts and cultural industries help define who we are as a nation. They enrich our quality of life and help create a thriving society. They have enormous benefits and bring enjoyment to millions'. I quote Tony Blair in the introduction to the Labour Party's document *Strategy for cultural policy, arts and the creative economy*. The Prime Minister believes passionately that the arts and culture have for too long remained outside the mainstream – just an optional extra – and that their huge potential has gone unrecognised by government. Above all else, this is what we in the Labour Party aim to change. We want to exploit the potential of the cultural industries to the full and to fuel the engine of the creative economy.

To achieve this, we will need to enable the Department of National Heritage to play a pivotal role in sponsoring the whole of our cultural output, including areas such as publishing, architecture and design. We also recognise that the arts are crucial to the task of re-establishing a sense of community, of identity and civic pride. We want to work in close partnership with the Regional Arts Boards, the Local Authorities and other agents of change at local level.

Our artists, designers, actors, writers, film directors and technicians are clearly some of the best in the world – the recent Oscars have proved this. The cultural industries in which these people work create wealth and employment on a significant scale,

are among the most profitable sectors of the British economy, directly employing an estimated 648,000 people, and have a turnover of around 7 per cent of GDP. Great Britain generates a staggering 20 per cent of worldwide music. The arts are what attract tourists in their droves to our shores and they are also responsible for attracting inward investment to this country through the contribution they make to the quality of life.

As the multimedia industries develop, there is increasing potential to exploit our creative strengths within an enabling governmental framework, to make the most of the export side of our creative economy. We have one huge advantage on our side, and that is the English language. With people all over the world clamouring to learn English, we should aim to use all the tools, such as the British Council and the BBC World Service and the Open University, at our disposal to sell ourselves and our products. Design also has a crucial role to play here. We produce extraordinarily talented designers in the UK, and the RSA has itself done much to encourage British industry to use this talent through their excellent Student Design Awards scheme, but we must continue to convince UK industry that good design gives competitive advantage. Likewise we must make sure the opportunity afforded by the Lottery to fund public projects provides a showcase for our best architectural and design talent.

People are at the heart of our cultural policy. We want to rebuild our sense of community, and I believe that the arts can make a real difference. We live in a multiracial, culturally rich and diverse society. We should be celebrating this richness. Likewise we should be encouraging the thriving amateur and voluntary communities who can not only give pleasure but also add purpose to our lives.

Urban regeneration and social regeneration can be delivered through the arts, through community projects, arts centres, and amateur groups, but we must start with the young in order to cultivate (instead of stifle) all that creativity, impulsion, imagination, lack of self-consciousness that all young children

naturally possess. The arts in schools are a vitally important way of nurturing and developing these natural tendencies and, sadly, this is an area that has been badly damaged over the last 18 years. Since the last war we had built up an enviable reputation for our music teaching; our school and county bands were thriving and in fact the European Youth Orchestra had considered imposing a quota on UK students in case they took over the orchestra. Likewise Theatre in Education was bringing live theatre into schools, bringing to life school texts and inspiring our next generation of thespians. The RSA's report *Guaranteeing an Entitlement to the Arts in Schools* demonstrated that the arts in schools have suffered. Peripatetic music teaching is no longer free in the majority of Local Education Authorities. Theatre in Education has almost disappeared, school visits to theatres and galleries are more difficult to arrange, arts advisory teachers have been decimated – which all means that both the arts within the curriculum and the extra-curricular activity have been detrimentally affected. These are our future artists, these are our future audiences and we ignore them at our peril.

Almost as important, the arts are a unique and essential part of the curriculum and, as Professor Elliot Eisner argues, can help teach the skills and competencies that business says it is crying out for – flexibility, good communication, self-confidence and creativity.

We must reverse the decline, and we propose that schools produce within their prospectus an arts statement sharing what extra-curricular creative opportunities (ECCOs) they provide. We will encourage all public and private arts organisations in receipt of public grants to publish an annual statement of what they can offer schools in their area. Therefore, for the first time, schools and parents will have a comprehensive view of what is on offer to them and to young people.

We will find a way to train more effectively and fairly our aspiring future artists and, particularly, to find a permanent resolution for the anomaly of discretionary dance and drama awards. To help young people further and encourage individual artistic talent and promote excellence, we intend to set up a

National Endowment for Sports, Technology and the Arts (NESTA) with National Lottery money.

I want to see the rich diversity of our cultural life become really accessible to everyone. This means looking at the current barriers, whether they be ticket prices, lack of disabled access or perceptions that some art forms are élitist. There are two particular initiatives that I am very keen to pursue. On a Monday night, when audiences are traditionally quite thin, I want to encourage theatres to make seats available in return for voluntary donations for as much as can be afforded. This has already been tried successfully in a number of theatres which, by attracting a much larger audience than usual, have not experienced a drop in revenue and, indeed, have often increased box office takings. The Government also places the highest priority on promoting access to the arts and developing new audiences. I am very keen on the concept of an Arts Card, which could be aimed primarily at 16- to 19-year-olds, the time when many young people give up their interests in the arts. The Card would open up new opportunities for getting information to them about what is on offer, and provide a way to link together existing concessionary schemes and develop new ones, so that the young – often not earning a wage – are not excluded by cost.

The arts for me carry forward the values and beliefs of our past into a creative future. They transform the way we see our world: they transform us through them and we are able to enter the imagination of others. The arts are important for themselves, but they are also important as the creators of a healthy and wealthy society. That is why I have devoted myself to supporting them. I see a new and exciting opportunity, as we increasingly trade in ideas as well as goods, to use our strong artistic talents to develop this new creative economy.

June 1997

THE
ARTS MATTER
LECTURES

A MESSAGE FROM CRAYOLA®

Sponsors of The Arts Matter Lectures

We believe that the arts both enhance and influence every aspect of our lives, and, in particular, that by guaranteeing an arts entitlement in schools we will help to provide the creative, stimulated and innovative adults of tomorrow.

Crayola® has taken much pride in endorsing this lecture series and hopes you will find these transcripts not only absorbing and compelling reading but an ongoing source of stimulus for thought and debate.

In such a series we have supported a wide and diverse range of topics, all of which demonstrate the value of the arts to our lives, whether in our heritage, our recreation or our workplace.

Our thanks to everyone who has made this series possible.

Mike Smith
Managing Director
Binney and Smith (Europe) Ltd.

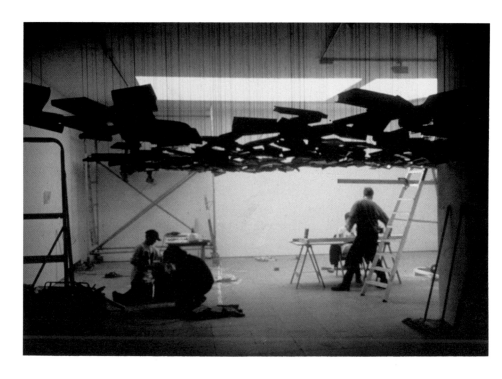

Richard Wentworth and his children preparing *False Ceiling*. The arts are an essential prerequisite for a healthy nation, a healthy economy, and a healthy life for every individual, and cannot be regarded as optional additions to the school curriculum or to our lives in general.

THE ARTS MATTER
LECTURE SERIES

ERIC BOLTON

Chairman of the RSA Arts Matter Steering Committee

Under the generic title The Arts Matter seven lectures took place at the Royal Society for the encouragement of the Arts, Manufactures and Commerce. The series of lectures were a follow-up to the RSA report *Guaranteeing an Entitlement to the Arts in Schools* which had revealed that, despite rhetoric to the contrary, the arts are the first subjects in the curriculum to be regarded as disposable at worst and optional at best.

In the light of these findings the RSA felt that it was vital to state publicly and unequivocally the importance and necessity of vigorous and vibrant arts to the health and wealth of the nation; to the quality and effectiveness of its education service; to its civic and communal life; and to the quality of individual experience and personal lives.

In planning the series, the ruling hypothesis was that the arts, being about serious business, are central to civilised living, not more or less entertaining distractions to be bolted on at the margins of life's main concerns and action. They are, in short, a unique and sustained exploration of the human condition. To flesh out that hypothesis the lectures set out to show, in their very different ways, that the arts are important in their own right, and not because of any worthy, but secondary, justifications for their importance. They constitute a particular way of explaining human motivation, experience, behaviour and the world in which we live. Implicitly and explicitly the arts, separately and collectively, ask and seek to

answer the question of what life is about. That sustained palimpsestic exploration of life and its purposes, carried out by and through the arts, is complementary to, and different from, and every bit as important and necessary as the examination of the natural world conducted by and through the sciences.

Involvement in, and with, the arts can have important and beneficial consequences for the quality of our lives, personal relationships, work, and education. In addition, the processes and outcomes of the arts fill much of our leisure time. But those are not the prime purposes of the arts. Important as those might be, the arts do not exist primarily for our comfort – to bolster up received wisdom, or our prejudices. To have integrity and vitality in themselves, as well as to do those other secondary things attributed to them, the arts must push and worry at the frazzled edges of the human condition. In doing that they might, as Yeats put it, 'Help ease the dreadful loneliness of man', or, according to Nietzsche, 'force us to gaze into the horror of existence, yet without being turned into stone by the vision'.

We cannot expect arts that are going about such work to have perfect table manners, to be unfailingly polite to authority, nor supportive of the ways things have always been done. The arts working to their own agenda do not sit comfortably with politicians and the state, private and public patronage, formal education, or conventional morality. Yet, ironically, when art and artists are constrained and directed by other agenda – political, religious or business – their contribution to those other, important but secondary ends is least effective. The treatment and roles of the arts and artists in totalitarian societies, and in places and times of strife and social breakdown, are all too illustrative of that.

It is this advocacy for the arts which is the over-arching theme of The Arts Matter lecture series: namely that if the arts are to carry out effectively those wider, beneficial tasks for individuals and society that are of such abiding interest to politicians, captains of industry and educators, it is imperative that the arts themselves are

thriving and able to go about their prime business with integrity and conviction.

The Arts Matter lectures, which took place at the end of 1996 and which are printed here in edited versions, explore the essential integrity of the arts, and the crucial links between art and its 'circumference'. They stress the fact that the arts are empowering, in personal, social and corporate ways.

The lecture 'From Public Purse to Private Patronage', the third Arts Council of England Annual Lecture, was given as part of this series by Deborah Bull, Principal Dancer with the Royal Ballet. She chose to answer the question asked by a man from Leeds, unemployed and with six children, in response to the public announcement of lottery funding for the Royal Opera House: 'What do the arts offer me?' In a cogent and sincere response, Deborah Bull provides the answer and asks that people be allowed through interaction with the arts to realise their own human potential and to find self-expression through creativity.

In 'Why Young People Must Have the Arts', Ruth MacKenzie, Executive Director of the Nottingham Playhouse, describes practical partnerships involving young people, artists and local funders in a variety of artistic work which can be both remedial and preventive, and which encourage young people to develop their own artistic skills.

With empowerment as one of its main themes, Sir Alan Cox, ex-industrialist in the steel industry, exhorts the business world to allow the workforce the space and scope to solve problems in a forward-looking, creative and dynamic way. He suggests that the arts have much to show industry and business about working at the competitive edge. Artists coming into contact with companies can bring lessons of creativity and decision-making, show how to build on failure and how to be innovative and forward-looking about productivity.

In 'The Unofficial Education of Art' Adam Phillips, the noted psychotherapist and author, looks at the complex relationship which exists between the artist and the scientist, that sharing of the

wish to make meanings that will sustain their love of life and allow them to act and feel as individuals. The arts can assist people in exploring the boundaries between common sense and the imagination, 'to tolerate conflict without too hurriedly resolving it'. Adam Phillips' conclusion that 'the arts teach us not to be over-impressed by the facts of life' is a thread running through many of these lectures.

The theme of empowerment returns in Chuck Mike's lecture, 'What Goes Around Comes Around', in which the need to empower others through contact with the arts is stressed several times. The theatre director and community artist gives practical illustrations of his work with poor rural communities in Nigeria and of the importance of helping them to find a voice and the self-confidence to tackle severe social problems within their communities and find their own solutions.

In the opening lecture of the series the Rt Hon Virginia Bottomley, MP, then Secretary of State for the Department of National Heritage, gives her view that a strong healthy country must have a strong healthy artistic life, and underlines the importance the arts have assumed in the context of regeneration, enterprise and economic development. Her conclusion that 'without art there can be no meaning to civilisation' and that 'our duty is to transmit to future generations the value of the arts so that art inspires our future' is echoed throughout the series.

The lecture delivered by Richard Wentworth, the sculptor, involved listeners in a powerful visual experience which encouraged them to see with the fresh eyes of a child and turn their expectations upside down. Because it was primarily visual and interactive this lecture is not reproduced here, but its themes and images are represented by Richard Wentworth's works and photographs, which illustrate this book.

The RSA's maxim that The Arts Matter has found articulate and influential champions who are diverse in discipline but united in their endorsement of the arts as an essential prerequisite for a healthy nation, a healthy economy, and a healthy life for every

individual. They underline the fact that the arts will, and must, go about their business to fulfil all or any of the roles ascribed to them. Above all the arts should not and cannot be regarded and treated as pleasant, harmless additions to our lives only where time and money allow.

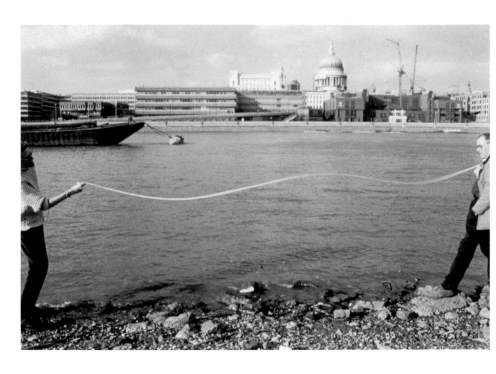

Exploring synergies between the arts and the built heritage: architect
(Peter Thomas, left) and artist (Richard Wentworth, right) take a hand in
finding a form for the new bridge between Bankside and St Paul's that could
put a leisurely wiggle into crossing the Thames.

OUR HERITAGE, OUR FUTURE

THE RT HON VIRGINIA BOTTOMLEY, JP, MP

Former Secretary of State for National Heritage

*(This is an edited version of the lecture delivered by
the Rt Hon Virginia Bottomley, then Secretary of State for National
Heritage, on 14 October 1996 to open The Arts Matter series of lectures.)*

The arts matter to all of us because they are the means by which every great civilisation expresses its highest aspirations. The connection between Art and Enterprise is enshrined in the foundation of the Royal Society for the encouragement of Arts, Manufactures and Commerce. The Department of National Heritage was founded in April 1992 by the former Prime Minister, John Major, as a demonstration of his view that:

> Man cannot live by GDP alone A country can only
> be strong, healthy, and contented if it burnishes its heritage,
> encourages its citizens to pursue excellence in sport and
> cultivates widespread appreciation of the arts. . . . It was in
> that spirit that I set up the Department of National
> Heritage. Its creation was a sign that Government should
> take such activities seriously. For millions of people, they are
> not optional extras, they are worth valuing in their own
> right.

During its first few years of life, the Department of National Heritage was called many things: the Department of Nothing

Happening, the Ministry of Fun, the Department with responsibility for what people choose to do in their spare time; but it is a hard-working department which has produced a body of serious work. It is, of course, true that the arts, sport, reading and voluntary service are activities in which many people engage in their spare time, but that is not the definition of their value. The existence of a strong and lively cultural life demonstrates the quality of the nation's life. The establishment of a government Department was evidence of the growing importance which the arts have assumed in the context of regeneration, enterprise and economic development because the DNH is as concerned with economic and social questions as with cultural ones.

Robert Hewison said that Britain has had a policy of not having a cultural policy ever since January 1940.[1] This does not imply we had one before that date, but that we have made a specific virtue since then of not having an express one – rather like the constitution. Mr Hewison went on to say that having a 'cultural policy means having a vision that encompasses ideas, images, values, that encompasses both artists and audiences and which has a long-term goal of improving opportunities for creativity, and of giving as much access as possible to the productions of that creativity'.

That has been the policy of the Department of National Heritage. Much of what my predecessors and I have done at the DNH has been to increase access to and understanding of the arts for audiences and artists.[2] We published key policy documents on the arts and young people – *Setting the Scene*[3] – and on museums – *Treasures in Trust*,[4] as well as two policy documents on sport.[5] Beyond that, work has been about strengthening the case for art by encouraging people to explore the synergies between the arts and the built heritage, the arts and sport, the arts and museums and between the arts and broadcasting.

1996 marked the fiftieth anniversary of the Arts Council. In wartime, the public funding of the arts performed wonders in encouraging community and national spirit. The founders of the

Arts Council believed that the same could and should happen in peacetime. Keynes, the first chairman, did not need any reminding of the links between economic forces and the arts. But it was not the economic argument he deployed. Of the foundation of the Council he said:

> We look forward to a time when the theatre and the concert-hall and the gallery will be a living element in everyone's upbringing, and regular attendance at the theatre and concerts a part of organized education.[6]

Time has reinforced our commitment to this aim.

Government has a vital role in creating the conditions in which the cultural life of the nation can flourish and in which what was once available only to the privileged few is available to everyone. The Tory Government has added to the strength of the national economy the great step change for the arts of the National Lottery – an unprecedented opportunity to which I shall return later. It has involved itself in setting out its policies and objectives for the cultural sector not only for intrinsic reasons but also for economic and social reasons.

The arts in Britain have no need of protectionism or quotas; the quality of our arts is well recognised. A disproportionate number of world-renowned sculptors and painters of the younger generation are British. Antony Gormley, Damien Hirst and Rachel Whiteread are just three with an international reputation, and these follow an established generation of artists of world standing: Anthony Caro, Lucian Freud and Howard Hodgkin.

In a democracy, politicians are well advised to be sensitive to the views of the electorate. Artists are different. New art works and forms have sometimes challenged the current consensus, the conventional wisdom and unthinking political correctness. Government must create a framework in which the experimental is supported. Georges Braque said 'All art is meant to disturb.' Even Mozart's patron told him he had used too many notes. When Whistler painted his nocturnes, he was accused by John Ruskin of

throwing a pot of paint in the public's face. In 1994, when the pictures that featured in the subsequent trial were in the Whistler exhibition at the Tate, the doors had to be closed to keep the crowds of enthusiasts under control. Whilst work which sets out merely to shock, or to be a sensation, is unlikely to endure, when artists simply reflect consensus we should worry for the state of our arts.

There is a tendency for the role of Secretary of State to be seen as relating only to the subsidised sector. It is important that it is a role which champions the arts in general. There are close links between the amateur and the professional, the subsidised and the unsubsidised, the national and the regional. Cameron Mackintosh has persuasively said, 'a tremendous talent base has developed through the UK's network of subsidised theatre companies. And it's here that actors, directors, designers, technicians and management learn their craft'.[7] These people move easily, as nowhere else in the world, between the subsidised and commercial sector, and they are acknowledged as the best in the world.

One of the founding principles of the Arts Council was the arm's length principle. The Government appoints the Arts Council, and the Government provides the money. What the Arts Council decides to do with the money is then out of the Government's hands. That is a rather oversimplified view, but it is true that the Minister who attempts to intervene in the individual allocation decisions of the Arts Council does so at her or his peril. With the memory of the German, Italian and Russian regimes of the 1930s still fresh in everyone's mind, there was surely no alternative to an arm's length principle in 1946. But is it still valid? Should we examine it again? I return to Maynard Keynes, who said:

> The artist walks where the breath of the spirit blows him.
> He cannot be told his direction; he does not know it
> himself. But he leads the rest of us into fresh pastures and
> teaches us to love and enjoy what we often begin by

rejecting; enlarging our sensibility and purifying our instincts. The task of an official body is not to teach or to censor, but to give courage, confidence and opportunity.[6]

The Arts Council was established to perform that role. No Heritage Secretary will find the relationship easy. There will always be occasions when a politician will want to be the breath that blows the artist, or the hand that directs the Arts Council. No-one who visited the exhibition Art and Power at the Hayward Gallery will have any doubt of the dangers which always lurk when too close a relationship is established, but arm's length should surely not mean indifference. The National Heritage Select Committee said: 'Secretaries of State open to accusations of meddling are far preferable to ones who do not care enough to want to meddle.'[8]

The arm's length bodies need government to set a policy context in which they can operate. That is why the Department has issued policy documents on the arts, museums and libraries. *Setting the Scene* was a collaboration between the DNH, the Arts Council and others. It provided a framework within which the grant givers and the practitioners could work.

Robert Hewison, again, described what he called the lack of institutional clarity in this country's arts as 'very much part of our culture' and acknowledged that it had its virtues. 'It is gradualist, it is pragmatic, it is empirical, it is founded on tradition and precedent. Above all, it is pluralist.'[1] I think these are strengths. In particular, the plural approach to funding the arts in this country has a beneficial effect.

For many years, cultural development in this country has been based on partnership. Arts organisations have looked to a plurality of sponsors and funding sources, and that is one of the reasons why the arts are so healthy and diverse in this country. We have business sponsors, local and central government, the formidable contribution from the National Lottery, private patrons, philanthropic foundations, and – never to be forgotten – the contribution from the paying customer, the audience; this is a mix

of funding where each adds value to the others. This not only helps when one source of funding is under pressure, but goes a long way also to maintaining artistic freedom and diversity, which are early victims of monolithic patronage.

Partnership goes beyond funding. One of the greatest success stories of recent years has been the rise of business sponsorship, in itself nothing new. Increasingly, business and the arts are finding other ways of helping one another, to their mutual benefit. Early in 1996 I launched the Business in the Arts/NatWest Board Bank whereby business men and women can bring their expertise to bear on the boards of arts organisations. The arts have long recognised the need to run themselves in a businesslike way and initiatives like Board Bank give them the opportunity to recruit board members with appropriate skills. And business too can benefit in many ways. As Professor Charles Handy said after working with the London International Festival of Theatre:

> Sometimes management suffers from an excess of
> rationality, an overdose of the familiar, an obsession with
> tidiness and a belief that more money will solve anything.
> It is as well to be reminded that there are other ways of
> making things happen, that a round of applause can mean as
> much as a cheque and that it is possible for ordinary people
> to make magic if they care enough about what they are
> doing.

Arts sponsorship is not a one-way deal. It is not just about writing or receiving cheques. At its best, it brings together the diverse talents, skills and experience of individuals who have much to learn from one another.

Nevertheless, money does matter. The DNH has stressed the importance of partnership in putting together new funding packages. Often now, the National Lottery acts as a catalyst, bringing together agencies and organisations: money from local government, central government, private sector sponsorship and the European development funds. And Lottery money is enabling

communities to realise their dreams. In less than two years, over 10,000 projects have benefited from Lottery awards. Theatres, brass bands, arts centres, films, galleries have all been given an injection of money that would have seemed impossible only a few years ago.

It is not too fanciful to see a parallel between the National Lottery and the great patrons of the past. As Sir Ernest Hall – a prominent contemporary patron – has said:

> Through the Lottery we have an opportunity to do for our towns and cities what the enlightened patronage of the Papacy and the Medicis did for the cities of Italy. We can realise Blake's dream of making England 'an envied storehouse of intellectual riches'.[9]

We should not underestimate the size of some of the projects coming forward – projects like the Salford Arts Centre and the development of the waterfront in Bristol. These are developments that will change not only the shape of the cities in which they are built but also the cultural landscape of the region and, by creating jobs and boosting local economies, change the lives of the people who live near them.

We must all understand that the new money that the Lottery has brought to the arts has brought with it new obligations. The arts community must work even harder to maintain public confidence and ensure that they seek, without loss of integrity, to engage the interest of Lottery players.

Beyond all this, there are partnerships that span the globe. Both the BBC and the British Council are close allies of the DNH. The BBC is one of the most important cultural agencies in the UK and our most audible – and increasingly most visible – ambassador around the world. The British Council, by extending the use of the English language, by promoting cultural exchanges and partnerships, and by demonstrating to the world the vitality and excellence of the arts in Britain, helps maintain our pre-eminence, and contributes to the competitiveness of Britain as a world nation.

A visiting exhibition or play from Britain acts as a present-day ambassador and trade mission. More people may visit a Victoria & Albert Museum exhibition in Tokyo than in London. In Paris, the Bacon exhibition and the exhibition of British sculpture in the Tuileries were a sensation. Paris, once known as the leading cultural capital, now looks with admiration to London. The arts are blossoming here as never before. A recent *Times* editorial urged the nation to 'flaunt it'.[10] I agree.

Let me now turn to the reasons why the arts should matter to all of us. In doing so, I do not propose to ascribe an order of priority.

The first is the economic significance of the sector. Keynes did not base his case for the Arts Council on economic arguments. He had no reason to, for immediately after the war it was the restoration of the manufacturing base and the huge amount of reconstruction work that were to provide jobs for the foreseeable future.

The scale of change since then has wrought a world that Keynes would hardly recognise. The arts today are a flourishing industry and a major source of employment not just for creative people but for support staff and service providers as well. Around 650,000 people are employed in the cultural industries. Lord Gowrie suggested in a lecture here nearly two years ago that the subsidy cost per job in the arts is only one tenth of that in agriculture.[11] The economic achievements of the arts – in overseas earnings, in encouraging tourists to these shores and in regeneration projects – are more important to the country's well-being than those of many of the traditional industries. The arts, leisure and tourism together are one of Britain's largest sectors; they rank with oil, pharmaceuticals and financial services. Some figures for London illustrate this well. The turnover of the main arts and cultural industries in London is £5.5 billion, about 6 per cent of London's GDP.[12] Other cities throughout the country from Newcastle and Liverpool to Plymouth and Bristol, have produced equally impressive figures.

Single arts bodies can have an extraordinary effect on local economies. The Tate Gallery St Ives not only provides a beautiful setting for some wonderful pictures but has also boosted the economy of St Ives by around 5 per cent, and the economy of Cornwall as a whole by about 2 per cent. When the new Tate opens on Bankside along with the new Globe and the other changes along the South Bank, it will have a profound effect on the economy and well-being of Southwark and South London as well as contributing positively to the balance of payments.

It is worth quoting here another extract – which I strongly endorse – from the report of the National Heritage Select Committee on the funding of the performing and visual arts. Select Committees are, for the most part, rather dry bodies whose language is carefully chosen to reflect consensus. This quote shows the extent to which the arts encourage non-Parliamentary language:

> The arts are their own justification. Music, drama, poetry, paintings, sculpture elevate the human spirit and enrich life. While everyone has to cope with pressing mundane preoccupations – whether in health, job or care for children and elderly parents – works of art in their widest sense show that life can hold more for us than the simple common pressing need to make ends meet and survive from day to day . . . The arts are part of our heritage. They tell us where we came from and they signify the direction in which we are going. They illuminate our past and foreshadow our future. They are our history and our horoscope. They have a spiritual dimension.[13]

An appreciation of the arts, heritage and culture separates us from animals and mere machines. By training I am a social scientist and, in many ways, that training informs my view of the role of the arts. Alienation begins where an understanding of culture ends. A society that fails to comprehend the past, that cannot grasp the continuity of human achievement, can have no bearings on its

forward journey. It is in fact not a society at all, only a collection of fragments. Perhaps the arts matter most of all because of the part they play in binding those fragments together, in giving us contexts as individuals, and in providing society with an identity. The sense of united purpose and reward that community arts groups can bring to individual schools, estates, streets and villages is well known. The same is true of the nation as a whole. The unparalleled creative heritage of our forebears is all around us and our vibrant contemporary arts enliven the present and will speak to future generations of who we are.

An additional dimension in the current arts world is the contribution made by the diverse artistic traditions of other cultures. Many of our art forms are benefiting from the injection of energy that they bring. At the same time those who come from other cultures can, through the arts, maintain and develop their own sense of belonging within the wide range of cultures represented in Britain today.

One hundred and fifty years ago Karl Marx believed that man was defined by the workplace, that his employment defined his life. This is no longer a tenable view. Healthier and longer lives, more flexible working patterns, improved educational opportunities at all ages, the dispersal of wealth, smaller families, increased personal mobility and the advent of the multimedia age – all these mean that in future we will be even less defined by our occupation than by who we are and what we choose to do.

If we are to have a population able to find fulfilment and responsive to the future needs of employees, it is vital that young people are introduced to the arts as early as possible. Through the creative arts young people learn to develop imagination, flexibility, expression, to communicate and to work together. These are the problem-solving, creative skills that will be required for the twenty-first century. Furthermore, the motivation that results from discovering the creative arts can be transferred to other subjects. There is now clear evidence of a close relationship between arts education and improvements in performance across the academic

spectrum. So the arts can help in developing traditional work skills as well.

Setting the Scene provided an action programme for enhancing the arts in education and demonstrating the importance of the arts in developing the citizens of the future. There is an impressive range of activity already under way in schools, but we must open new eyes, to unlock the creative side of young people's personalities and to encourage them, having developed an interest in the arts in school, to maintain it in later life. An awareness of the need to make available ways of developing the interest and talent of young people led me to change the Lottery directions so that Lottery money could be invested in human capital as well as in the physical infrastructure of the arts.

As part of our programme of action, a forum has been created as a joint undertaking with the Royal Society of Arts to bring together all those with an interest in the arts to inform the process of government policy-making. There are many organisations involved in the arts working in their own spheres. This forum will be a means of cutting across boundaries and bringing together those groups to discuss issues of interest. Those discussions will enable us to tap into an extensive network of expertise and experience.

The arts are founded in local activity taking place all over the country. Tremendous enthusiasm and energy are the hallmarks of the amateur and voluntary sector, and there are endless opportunities to draw young people in.

Despite being deeply individual, the arts also provide the ability for individuals to come together. An orchestra or a theatre provide the opportunity for participation and communal activity which appeals to our deepest instincts. At school prizegivings I cite the orchestra and the choir as examples of commitment, motivation and teamwork. I am pleased to see that this is a point stressed by Sir John Harvey Jones in a recent management book.[14]

To maintain social cohesion, to give people a sense of purpose through their working lives, we need to focus on the causes that provide a sense of belonging to a group and value to individuals at

times of change. Lifetime learning, which provides self-enhancement as well as enjoyment (and which the RSA is promoting so effectively through its Campaign for Learning) is of profound relevance. The development of new interests and new skills throughout working life and into retirement will not only fit people for the challenges of the new styles of working we are beginning to see but will also stimulate creative and intellectual activity – ensuring that we can each continue to grow as individuals and make a worthwhile contribution to our community.

In the United States, at the Baltimore Museum of Modern Art, I was impressed by the degree to which they have taken the message of the value of art to some of the most disadvantaged families. 'Artful grandparents' is an initiative to encourage grandparents to accompany their grandchildren to exhibitions. It should be adopted in this country. Grandparents have the time to reflect and wonder with their grandchildren. Such a scheme builds links between the generations; it inspires.

Bringing people together through the arts clearly promotes a sense of community. Investment in arts and heritage projects can promote social and economic regeneration in its broadest sense as well as give a community a new sense of self-confidence, pride in itself and a recognition of its potential. This is why partnership is so important. Look at what is being achieved in the North.

Visual Arts '96 is the title of the impressive campaign to use the arts as a springboard for the region. Led by Northern Arts with partners from the private sector, local authorities and the Regional Office, and bringing in money from Europe and the Lottery, they have established a model for other communities. The message from the North-East and Cumbria is that this is a lively, creative part of the world. Quality of life is valued. It is a good place to live and work. The new Glass Centre at Sunderland, for example, will provide a community dominated for generations by the shipyards with a major focus and a lasting reminder of the area's long and close involvement with glass and glassmaking.

Old traditional buildings are being used for new purposes. There are plans for the Baltic Flour Mills on the south side of the Tyne in Gateshead to become a gallery for contemporary art. Across the country we now see increasingly the use of traditional buildings for new purposes associated with the arts.

At times of such rapid technological and scientific change, the use of familiar landmark buildings for modern uses provides continuity and stability. Ours is not only a country with a proud history, with traditions and values dating back many centuries, but also a country not afraid of change, a country facing the future with belief in itself and confidence that this generation will also create landmark buildings for its own time and to pass on to future generations. Here, too, we have magnificent examples like the new arts centre in Milton Keynes, the Lowry Centre and the Bristol waterfront, which will form the focal points for communities all over the country.

In London, Spitalfields provides an interesting case study of urban regeneration The restoration of the wonderful Hawksmoor church alongside the investment in the Spitalfields Arts Festival and the development of the new small opera house have brought back to life an almost abandoned area. People come from far and wide to join the local community in celebrating its strength and sense of purpose. In an address at Toynbee Hall,[15] I welcomed the growing focus on the arts and heritage as a means of social, economic and spiritual regeneration as well as the more traditional, paternalistic view of providing assistance in economically disadvantaged areas.

The cultural sector will provide many of the jobs of tomorrow. Creative and cultural education is vital for raising the rounded citizens of tomorrow. Through the National Lottery and other initiatives, old buildings are being brought back to useful life and new landmarks are being created. Beyond that, it is vital that we champion our new talent. We have reason to do so. Our architects are respected around the world. Any list of world-class architects must include Foster, Rogers, Hopkins, Grimshaw and Farrell.

Our film makers and stars win international prizes and plaudits. There is sparkling young talent in all the arts; we should be proud of them.

The future is bringing further, formidable technological change, especially in the area of communications and information technology. We can put a disk into a computer and look at the paintings from the National Gallery, zoom in on details, read the accompanying text and go at our own speed. The Internet is bringing the world's culture into our homes, schools and libraries; soon it will come in through our televisions rather than our computers. In a few years we will perhaps be able to look at the Getty Museum's collection in hologram in the middle of our living room. These developments provide new access to the arts. They bring their own sense of wonder, and we are working to encourage the pace of change so that multimedia can enable as many people as possible to experience areas of the arts and heritage that may have been denied them in the past. But I do not believe that watching on a computer or television screen can ever compare with the excitement of watching a live performance. Neither in my view will computers deter audiences from seeing an original painting or sculpture. On the contrary, it will stimulate interest in the real thing.

The arts communicate between nations and between generations. It is inspiring to see the part that the arts can play in times of austerity or repression. Study Sir Geoffrey Cass's account of the Royal Shakespeare Company production of Arthur Miller's *The Crucible* being performed in Poland, when under an authoritarian regime: it describes the ancient role of the arts in conveying a message to those oppressed by tyranny. Descriptions of music-making in the midst of shelling in Sarajevo, and the memory of the wartime concerts up the road at the National Gallery remind us of the life-affirming power of art.

Visiting the Hayward Gallery's Art and Power exhibition was a salutary reminder of the tyranny of authoritarian regimes and their hijacking and corrupt impoverishment of the arts. It also

brought home the indomitable nature of the human spirit, expressing itself against all the odds through creativity. I believe that the artistic excellence of today comes with a flourishing economy in which initiative, enterprise and risk-taking are valued. But it is the highest achievements in the arts that will continue to inspire and be revered by our descendants long after our social and economic achievements have been forgotten.

Euripides said 'Civilisation is not a gift of the gods, it must be won anew by each generation'. Without art, there can be no meaning to civilisation. Our duty is to transmit to future generations the value of the arts, so that art inspires our future as it has done our past.

The approaching millennium provides the opportunity for spiritual renewal and regeneration for individuals and communities. The arts and our cultural heritage must play a central role. It will be a time for us to celebrate our achievements, our abilities and our potential as we move into a new century. We are right to be proud of our cultural heritage; we celebrate the artistic creativity and cultural diversity of the present; and we must work in partnership to ensure that future generations benefit to the full from our rich legacy.

References

1 Hewison, R. (1996) 'Cultural Policy and the Heritage Business', a lecture for the Royal Society of Arts at Nottingham Trent University, 14 February 1996, London: RSA.

2 Department of National Heritage (1996) *People taking Part*, London: DNH.

3 Department of National Heritage (1996) *Setting the Scene: the arts and young people*, London: DNH.

4 Department of National Heritage (1996) *Treasures in Trust,* London: DNH.

5 Department of National Heritage (1995) *Sport: Raising the Game*, and *Sport: Raising the Game, the first year report* (1996) London: DNH.

6 Keynes, Lord (1945) 'The Arts Council: its policy and hopes' in *The Listener*, 12 July 1945.

7 Mackintosh, C. (1996) 'No public subsidy, no West End' in The Arts Council of England *Annual Report 1995–96*, London: Arts Council.

8 National Heritage Select Committee (1996) *National Heritage Select Committee Third Report, The Structure and Remit of the Department of National Heritage*.

9 Hall, Sir E. (1996), letter to *The Times*, April 1996.

10 *Times* leader, 9 May 1996.

11 Gowrie, Lord (1995) 'The Philosophy of Cultural Subsidy', Arts Council of England Annual Lecture, London: Arts Council.

12 London Arts Board (1996) *The Arts and Cultural Industries in the London Economy*, London: London Arts Board.

13 National Heritage Select Committee (1996) *National Heritage Select Committee First Report, Funding of the Performing and Visual Arts*.

14 Harvey Jones, Sir J. (1994) *All Together Now*, London: William Heinemann.

15 Department of National Heritage Press Notice DNH 269/96, 10 September 1996.

Investigating familiar ideas in unfamiliar forms: the arts provide a vital opportunity to experience the world through others' eyes and reach an understanding of that world.

From Private Patronage to Public Purse

Deborah Bull

Principal Dancer, The Royal Ballet

The American sociologist Edward Shils described the most important cultural change of the second half of the twentieth century as 'the entry of the working classes into society'[1]. As a consequence, and for the first time, the working classes were granted a voice. Shils could not have known quite how pertinent his sentence would be for me. My roots are firmly planted in the terraced streets which echo to the roar of the Saturday crowd at the nearby Baseball Ground, home to Derby County. Yet I have entered society, I have been given a voice and, on the occasion of this lecture, a microphone so that my voice can be heard.

The injustice of a system which judges a man's value by his social status has long been recognised. I shall not add my voice to that particular cause, but I will express my surprise over what the newly acquired voice of the people is saying. Over the course of the last two years, focused by the Lottery awards to artistic institutions, the man in the street has spoken loud and clear on the arts; or at least the tabloids have spoken loud and clear on his behalf, giving us such memorable headlines as 'Up your arias', and even more groaningly predictable, 'Tutu much'. I'm sure we are all familiar with the way the arguments go. The arts are élitist. They have nothing to do with our man in the street. They are the province of a closed circle of 'luvvies' who club together, in the words of Terry Dicks, and, as quoted by Lord Gowrie, Chairman of

the Arts Council, in 1995 in the first Arts Council Lecture, 'persuading successive governments to give money to the arts, and then use it to subsidise their own leisure at the expense of the rest of us'.[2]

Two years on, and the same arguments are regurgitated whenever the opportunity presents itself. They are not too difficult to refute. Lord Gowrie and I, along with Sir Jeremy Isaacs, did so with a convincing victory for the arts at the Oxford Union in January 1996.

But the tabloids continue their campaign, purportedly on behalf of the nation. I suspect I am not alone in my belief that they do not reflect the opinion of the British public. I believe rather that they seek to influence it, and unfortunately they do so with some success. If you throw enough mud, as we must all be aware, some will stick.

When the Charities Board was under fire for making awards that the tabloids considered an unsuitable use of the nation's Lottery pound, the Chairman of that board wrote in a letter to *The Times*: 'If you do skin deep surveys, you get skin deep responses'. In the same way, if you habitually make skin deep judgements and never delve further into the detailed reasoning which precedes any human action, including the awarding of Lottery funds, it is hardly surprising that those judgements are picked up and parroted in a similarly unquestioning fashion. So I generally listen to the voice of the 'common man', as reported by the tabloid newspapers, with some degree of scepticism. I have found that if an issue is explained in a humane fashion, rather than in the snappy and judgemental soundbites favoured by many areas of the media, human beings are usually capable of great amounts of humanity.

Having said all this, there is one image which has stayed with me for some months now which I can neither ignore nor forget. Amidst the furore thrown up by the public announcement of the Lottery grant to the Royal Opera House, my boss, Sir Jeremy Isaacs, gamely faced the wrath of the nation – via the telephone – on breakfast television. I held my breath as the calls came in, and

was relieved and delighted that most of them were reasonably positive about the award itself and about the value of the arts in general. The final caller was a gentleman from Leeds, if I remember correctly. He told us that he was unemployed and trying to raise a family of six children. The money available in his household did not stretch to opera tickets, and even if it had, one didn't get the impression that that was where it would have gone: 'What', he asked 'do the arts offer me?'

His question has haunted me, returning, unbidden, into my mind. The time allotted to Sir Jeremy meant that despite his best efforts, it remained largely unanswered. It is a question that will arise from time to time in a society which treats the arts the way we do. But it is a valid question, and one which all men of conscience within the arts have been obliged to face over the last two years. This evening I would like to search for an answer.

It might be useful to try to find the origins of this uprising against the arts in this country. The portrayal of the arts as a plaything of the rich, élitist and exclusive is more and more common. Certainly in the days of private patronage this may have been the case, although I personally doubt this to be the whole story. I suspect there may often have been an element of 'Robin Hoodism' in the relationship between patron and artist. Mozart, for example was supported by the Archbishop of Salzburg, and wrote appropriate music for his court. At the same time he developed ideas which were of importance to him, producing operas in the German language which were lapped up by the 'man in the street'.

In dance, the monopoly of Louis XIV's court ended around 1660 when convention finally permitted the highest nobility to perform alongside the professional dancers, whose reputation was described as 'so murky that the church would not marry or even bury them'.[3] From this point on, the history of dance would now be linked inextricably with its creators and interpreters rather than its patrons, however useful their money would continue to be.

Artists – including dancers – can and do come from all areas of the social spectrum. Artistic ability blossoms in the most unlikely

circumstances – artistry is a question of sensibility, not privilege. It is not passed on with the family silver. (Neither is business acumen, as many families have found to their cost.) There are myriad examples of artists rising above difficult social environments to produce extraordinary and lasting works of art. That they managed to get the wealthy to pay for their artistic development strikes me as very clever indeed. As many artists have derived in the past – and still do – from the working classes, the arts have in a sense long been the preserve of those classes. Getting the aristocrats to think it belonged to them – if they did – could be called one of the greatest frauds of all time. The creation of the Arts Council in 1945 put an end to that fraud. The enjoyment and benefits of the arts would no longer be the private domain of a few wealthy patrons. The government effectively purchased the best of the nation's art for the nation. Fifty years on, we now face a situation where it is not at all certain that the nation wants it.

There are still large numbers of people who, without being able to explain why, would endorse the importance of the arts to society. They would have a notion of what Frances Partridge called 'the importance of the classics, the indefinability of good'.[4] They would acknowledge culture and the arts as a legacy of our civilisation, binding us with the past and speaking for us in the future. They would understand the relevance of the arts as a national asset. And the arts should be a source of national pride. The artists in this country rank amongst the best in the world, and truly act as ambassadors when they travel abroad. Whilst doing so they contribute hugely to the balance of payments. After financial services and pharmaceuticals the arts are our biggest earner of foreign currency.[5] (A recent report suggested that we dancers make quite a large contribution to pharmaceuticals ourselves.) Music alone brings in £571 million from overseas earnings.[6]

The cultural attractions are a major feature in enticing visitors to these shores. Trevor Nunn, writing in the *Evening Standard*, has described 'tourism, especially cultural', as 'our biggest growth industry'.[7] Sixty-three per cent of the tourists who came to Britain

in 1994 rated our museums as an important influence on their decision to come here.[8] The knock-on effects to the rest of the economy are obvious – man cannot live on art alone. The cultural tourist's pound will be spent on food and accommodation as well as on entrance tickets. Tourism earned this country over £9 billion in 1993.[5] Presumably 63 per cent of that figure can be attributed to those cultural tourists.

The nation also benefits from the arts as a source of employment. Around 650,000 people work in the arts and cultural industries, which is about two and a half per cent of the work force.[9] Between 1981 and 1991 there was a 34 per cent increase in the number employed in the arts. This was in a period when the overall working population hardly increased at all.[10]

Beside all these facts and figures lies the issue of entertainment – we must not forget that a great many people enjoy the arts and find comfort, pleasure or a means of escape in an evening at the theatre or a day in a museum. Last year there were around 25 million paid visits to the theatre to see professional performances of drama, opera and dance. The box office income totalled over £330 million.[11]

These are all genuine and worthwhile rationales for the continued existence of the arts: well-rehearsed arguments which can combat many lines of attack. They tell us why the arts are a justified recipient of government funding. But they are not arguments for someone who is unemployed and unable to afford a theatre ticket. They leave the gentleman from Leeds with his question hanging in the air: 'What', he asked, 'do the arts offer me?'

We will only find an answer if we delve a little deeper. We must start by asking whether, as a nation, we are still able to appreciate the arts. I fear that without an appropriate education, we no longer have the ability to recognise them.

What is our national perspective on education? It seems to me that there are two opposing accounts.

The first sees education as an instilling of facts, a feeding of information, with the ultimate aim being the acquisition of a job,

and the teaching of knowledge which can be stated categorically as true or false. There are obvious holes in this system, not least of which is the categorical fact that facts change. My own geographical education must on a regular basis be renewed. Yugoslavia has gone, the USSR no longer exists. In mathematics, it is the rules which have altered. The widespread availability of the pocket calculator, and the fact that it can now be used in the schoolroom seems to make a mockery of the long hours I spent trying to learn multiplication tables. The early specialisation in a field of future employment revolves around a view of humanity as no more than the oil which ensures the smooth operation of the big machine of life. The mechanic fixes the car for the salesman, who sells to the supermarket, where the caterer buys the food, so the chef can cook the meal, which feeds the mechanic, and so on. You get the picture. It is a picture which ignores the very qualities which make us human.

With machines frequently replacing man in the workplace, it seems a nonsense to prepare young people for a career which, by the time they come to find employment, will probably be obsolete anyway. The technological world changes so quickly that we are automatically engaging in that nonsense if we employ this account of education. In the second Arts Council Lecture, Sir Ernest Hall described a world we are moving towards where 'the only reason to employ people will be to benefit from the qualities which raise them above machines'.[12] The premature shift of focus away from those qualities and towards vocational specialisation has uncomfortable echoes of the past age he described, when children were sent to work in the mines, sometimes from the age of five. Physically, our children are undoubtedly better off. Intellectually and emotionally, we are sending them to an equally dark and unhealthy place. Trevelyan's words ring truer than ever: We are creating a 'vast population able to read but unable to distinguish what is worth reading'.[13]

The second view of education has its definition in the very word itself, originating in the Latin 'educere' – to 'lead out'. This

implies that there is leading, and therefore a person to do the leading: a process in which there is human guidance. It also implies the encouragement of those things which are distinctly human: rationality and reason. An ability to make informed judgements. An education of the emotions. We are the only life form which has the ability to understand and make decisions about our actions. We are proactive rather than reactive. We do not simply respond to external events.

True education should provide the intellectual tools for independent thought, moral evaluation and rational judgements. In David Best's words, it should develop qualities such as 'curiosity, originality, initiative, cooperation, perseverance, open-mindedness, self-criticism, responsibility, self-confidence and independence'.[14] With this list, he articulates an initial aim. In addition, the acquisition of factual knowledge and skills will provide further stimulation and may, should those facts not become outmoded, have a relevance in later life. This is certainly not guaranteed. The facts we teach are revisable, and merely correspond to the work which goes on in the upper branches of the discipline.

This is not necessarily a fashionable view in a society which is increasingly dominated by relativism and its once-removed cousin, market forces. We are living in an age where 'better' or 'the best' are rarely recognised. If 'educated' is not better than 'uneducated', how do we justify the role of the teacher in leading the pupil from one state to another? How do we explain the purpose of education itself? The outcome – learning – would be in no way preferable to the original, un-learned state. The opinion of the pupil would, by definition, be of equal value to the opinion of the teacher.

And where market forces and accountability are such decisive factors, the idea of pouring money into an education system which doesn't have as its outcome a palpable measure of achievement would currently receive short shrift.

But the true values of education cannot be measured with ticks and crosses. E. M. Forster said that 'absolute trust in someone else is the essence of education'.[15] The gaining of that trust may be a huge

educational achievement in itself. The revelation of understanding which is demonstrated by no more than a smile or a gesture, or simply by the pupil's attendance, can be worth much more than an 'A' grade in an exercise book.

So in my account, an educated person is a person who has realised his own human potential, in contrast to one who remains narrow minded and closed to experience. A person who is able to make rational judgements and has a sense of values. A person who not only has knowledge but is able to make use of that knowledge. We should not forget that performing a given task involves deciding which procedures to best adopt in the execution of that task. The exercise of practical knowledge is therefore in itself an exercise in human rationality.

Tawney says all this much more succinctly than I do:

> The purpose of an education worthy of the name is not merely to impart reliable information, important though that is. It is still more important to foster the intellectual vitality to master and use it so that knowledge becomes a stimulus to creative thought. Also, it is partly, at least, the process by which we transcend the barriers of our isolated personalities and become partners in a universe of interest which we share with our fellow men, living and dead alike.

How does one formulate such an education, and thus achieve such a person? How does one provide an education of the emotions? Again I turn to David Best. He tells us that 'in exploring and learning new forms of expression, we are gaining and refining the capacity for experiencing new feelings'.[16] A critical response to the arts will always involve a consideration of the feelings which that art evokes. As the distinctive characteristic of art is that it reflects the important issues of life within it, it follows that an exploration of the arts will result in an increase in the knowledge of those issues and therefore in the range of feelings which those issues can arouse. Along with this refining of the ability to feel comes a refining of the ability to communicate feelings.

The late Dr Peter Brinson, in his 1989 RSA lecture, recognised the importance of the arts as a means of communication:

> . . . Non verbal forms of human interaction . . . are
> fundamental to the existence of human society and its
> historical interpretation . . . Knowledge is communicated
> through many different modes . . . including those which
> do not require verbal communication at all. Not to enter
> into these communities of discourse is to be disadvantaged,
> to fail to have been educated as fully developed, intelligent
> and feeling human beings.[17]

The developed, intelligent and feeling human being will be able to fulfil a basic human need: the need to communicate. Denial of this need through solitary confinement is a common form of torture. The ability to communicate is vital to our well-being. It is through thought alone that feelings become words, and words, even though they may never be spoken, are the basis of communicable actions. An education in the arts is an education of those processes through which thought may be developed. In addition, the arts are a wonderful medium in which to communicate those thoughts.

The widening of experience concurrent with an artistic education will lead to greater self-understanding, and the increased concepts available through a study of the arts will allow for greater understanding of others. Without this increase in the concepts that we can employ in our perceptions, we cannot begin to recognise the arts as art.[18] All our understanding is determined by the concepts available to us. If the notion of art is not within our repertoire, we may recognise art in some other, perhaps valuable way, but not as art. A whole avenue of understanding and communication is therefore disabled.

To clarify this, take the example of the London bus. If you were a time traveller, or a visitor from another planet, you would not be familiar with the idea of London Transport. The sight of something huge and red hurtling towards you at breakneck speed would inspire in you quite different emotions from those which fill the

weary commuter at the end of a day's work. Being familiar with the concept 'bus', he knows that the red monster will stop at his request, pick him up, and transport him to another place. (An analogy which actually has more to do with art than I intended.) Or, to elaborate in a different vein, if you were brought up in a country where snow is a regular and familiar occurrence, you would not perceive it in the same way as we do in Britain. You would consider it an efficient means of transport, a useful insulator, or a wonderful source of hydro-electric power. Our perception of snow is altered by our limited concept of its utilities. Our ability to recognise art is in the same way limited if the concept 'art' is not available. To misquote Peter Brinson: 'Art will not prosper in our society until it becomes a shared language'.[19]

Art can still be recognised and absorbed in other ways. It can be appreciated as an aesthetic experience, touching those parts within us which respond to physical beauty. But if dance, for example, offers only aesthetic stimulation, it is offering nothing more than gymnastics, or ice-dancing. I have nothing against either: along with the rest of the nation I enjoyed the remarkable achievements of Jayne Torvill and Christopher Dean, and will always remember Nadia Comaneci's series of perfect tens. But I hope that you will all join me in my campaign to ban the use of the phrase 'artistic interpretation' as it used in relation to the flirtatious antics slotted in between the diagonal tumbles of the gymnast's routine. Physical perfection decorated with a smile does not constitute art.

More importantly, art may encourage and stimulate self-expression through creativity. This in itself serves a vital function. We must all find some means of expression, and I believe that if we do not create, we will probably destroy.

Where is the capacity for expression in a society which becomes ever more homogeneous? Take a trip northwards along the M1. Go into any service station along the way and you will not know if you are in Watford Gap or Woolley Edge. Everything is standardised, a single synthetic statement which leaves no room for the variations in the personalities of the people who work there. The

individuality of the employee is denied, even to the point that he must welcome us with the official greeting of the service provider: 'Hi, I'm so and so. What is your beverage preference this afternoon?' Even the idiosyncratic place name which used to serve as our address is becoming redundant. You no longer live in the charmingly evocative Primrose Hill. You live in NW1. Numbers are replacing names as a means of identification.

All this is fine if you believe people to be robots: send them back to their zone, feed them pulp and bring them back to work to start the cycle over again. But none of us do believe that. So where is their individuality and creativity to find its outlet?

The only type of creativity which is left seems to be the creation of human life. Not only does it provide a sense of ownership, and a lasting legacy; it also gives a licence to notice and reflect once again on the good and joyous things in life. We freely use those things to communicate with our children – music and songs to stimulate, and movement to soothe. For some reason we abandon this line of communication as they grow up.

I am not recommending the arts as an alternative to parenthood. But I am recommending the arts as a means of fostering creativity and allowing us to see the individuality in each of our lives. Without that creativity, the only way to make our mark is through destruction.

Creative art has long been used as a remedial tool in prisons. Schemes such as the Koestler Awards recognise the enormous importance of self-expression through creativity and the part it can play in rehabilitation. We talk of art reflecting life: it does so not in the fashion of an overmantel placed so high that the reflection is never seen. It reflects life so that we may see ourselves within it, and having truly seen ourselves, reflect upon what we saw.

If art can be used in a remedial role, does it not follow that it could be used as prevention rather than cure? It can, and in some places, it is. There are several examples around the country of projects which use contact with the arts as a tool for change in the lives of those involved. In my capacity as a judge for the Prudential

Awards for the Arts in 1996, I came across one such project taking place in the North of England. Dance in Action was conceived in 1992 in response to the Henry Smith's Charity's desire to support projects in the North-East that would 'initiate new ways of combating the acute social deprivation prevalent in the area'.[20] The aim of Dance in Action was 'to turn around existing patterns of youth activity' and 'investigate the value of dance as a means of social reform'.[20] Over three years, 200 young people from severely disadvantaged social backgrounds have been recruited into 16 dance groups. They meet weekly and their activities often culminate in performance. For one group, which consists unusually of seven men and one woman, success in the regional heat of a Youth Dance Festival resulted in performances at the Queen Elizabeth Hall, and the chance to visit London for the first time in their lives. These young people, aged between 18 and 21 come from the communities which played host to the Newcastle riots in 1991. Most of them have been rejected by their families. The project has enabled a 17-year-old boy who left school without any GCSE qualifications above grade D (in his own words, 'I wasn't there much') to start a National Diploma in Dance – a two-year, full-time course at Newcastle College. This would not be so extraordinary if he had the benefit of a stable domestic environment, or at least the support of one of his parents. He has neither. The most remarkable thing about him is his clear determination to succeed: he has mapped out for himself a further four years of study to achieve his goals.

'Young people's life expectations have changed'[20] – anecdotal and subjective evidence, but the long-term success of the project can only be analysed and evaluated in the long term. The progression of one boy from truant to focused student is a powerful example of what is possible.

A similar example comes from Govan, an area of Glasgow which I have seen described as 'charismatic'. Earlier this year, a Canadian dance company worked there with an after-school youth group. Let me give you their own account of the experience:

> The creation of their own dances was the key to their
> dedicated involvement and self-discipline. It gave them
> something of their own to value, something for which
> they had to be personally responsible. Everyone worked
> together in teams, which challenged boundaries, trust,
> co-operation and respect for others. All the skills which
> are needed for such teamwork go beyond dance. They
> are the social skills required in a positive way in a wider
> world. One of the most outstanding successes was
> getting the children working happily together who
> don't normally mix or trust each other as a result of
> existing boundaries in the community. Personally we
> will never forget the warmth and generosity this
> community showed us.[21]

Subjective, yes, but compelling nevertheless.

I speak mainly about dance, as that is the area with which I am
most familiar, but I also believe that with its relationship to human
movement, dance has a particular part to play in human
development through artistic expression. With its fusion of mental
and physical effort it connects the organs of thought with the
instruments of human action. In many cases, physical action
can be employed to demonstrate thought long before words
can. It has always existed as a means of expressing intent, and still
does, often without the realisation of the participants, in courtship
'rituals' in discotheques and night clubs. Far from being the most
'élitist' of the arts, I believe it may actually be the most accessible.
We use movement and gesture throughout our lives: 'Dancing is
part of human history, part of the history of human culture, part of
the history of human communication.'[22] It is a concept with which
we are all familiar, even if the particular type of dance with which
we are familiar may not be an art form.

All dance may be a valid means of self-expression. It does not
follow that all self-expression is art, as this newspaper cutting
illustrates:

> There's this woman who's composing a dance for spring and
> she lists to herself all the wonderful things she's going to
> express through it. Then you see her dancing it, and there
> are two little boys watching and one looks puzzled and asks
> 'What's she doing?' and the other says 'I think she's trying
> to lose weight'.

Art must turn its self-expression outwards and encompass the
audience in that expression. It must speak in a unique voice which
is nevertheless understood by and increases the understanding of
others. It must connect. However healthy self-expression may be, it
is not necessarily art.

Art exists on a related but different level. It exists that we may
learn from it, and in doing so, learn about ourselves. It will not do
to imagine that these values are obvious, that the benefits of the arts
can be transmitted by osmosis. If that were the case, we would
simply send pupils to a local gallery and they would return to us
educated – transformed. We know this does not necessarily happen.
(Although, of course, it can. There are some people who show a
natural responsiveness to the arts. I have never heard this better
articulated than by Richard Hoggart's aunt – the soft, not the hard
one – who responded to the overture from *La Traviata* with the
exclamation 'eeh, it's music which makes you want to give all your
money away'. And there are the Leonard Basts of this world, the
ones who instinctively turn to the arts in the search for a passport
out of the drudgery of their own situation.)

I believe that we are all innately responsive to the arts, but that
our natural response is rarely nurtured, and is too often suffocated
in our early years. Where the flame has been extinguished,
experience in the arts needs guidance. It must be led by human
contact. You cannot simply throw art, even great art at people. It
will bounce right off their turned and stiffened backs. We should
have no aim for art as mass culture. It is the product of, and relates
to, those qualities which make us individual, not those qualities
which define a mass. But each mass is made up of individuals; we

infiltrate the mass by touching the individual. Without this personal contact, this guidance which comes with education, it is not surprising that the man in the street finds a difficulty in recognising the values and the benefits inherent in the arts.

If the values of the traditional and established sections of the arts are not recognised, what hope is there that any further development will be? As contemporary works are created, as they must be to ensure the continued relevance of the arts, we move further away from a body of people who do not have the mechanisms to move with us.

In a climate which demands accountability, the creative elements in the arts are seriously threatened. If we must answer to the paymaster, the box office, or the sponsor, programming will always err on the side of safety. Risks will simply not be taken. Commercial sponsorship will only in rare cases be directed towards work which is new, difficult, and therefore 'risky'. If the philosophy of sponsorship is expressed as a 'payment by a business firm for the purpose of promoting its name, products or services',[23] it obviously follows that such a firm will seek out those performances which will most cost-effectively fulfil that purpose. In nine out of ten instances, this will be a known best seller which will both succeed at the box office and at the same time delight the sponsor's guests and their spouses. This leaves the business of funding the innovation, the risky bits, to the Arts Council alone, which in turn leaves it open to the criticism that too much money goes to 'difficult' or 'élite' art, and not enough to the 'people's choice'.

Without risk there can be no advancement, and without advancement, there will be no heritage for the future. The arts will cease to be socially and politically relevant, and they will cease to speak to us and for us. True art will rarely be accountable in the marketplace. This does not mean that we cannot account for its value.

As R. G. Collingwood said: 'The work of art proper is neither seen nor heard.'[24] How can it therefore be quantified? Its real work lies in allowing us to see the options which are open to us as human

beings, regardless of the restrictions which our circumstances or upbringing would seem to enforce. There are other things that can do this, too: I would not argue that personal growth is the unique preserve of the arts. Other experiences can bring about a broader vision of the choices available in our lives, and of the issues which are important in it. Religion is one such experience; love is another, but love unfortunately requires reciprocation, which may not always be forthcoming. (I do not think we can lobby for a Department of Dating.) So there is art, and specifically the increased knowledge of life, and the refinement of the feelings it inspires which an exploration of the arts can provide.

Can all this be put into practice? In our overcrowded and underfunded schools can we strive for an education system which stresses human rationality and the development of the emotions through the arts? Tony Blair said in the wake of the 1996 Labour Party conference that 'without a first-rate education we cannot have a first-rate economy'.[25] He may be right. But I would say more specifically that without a first-rate education we cannot have a first-rate human being. It may mean more investment in the short term, but in the words of Don Foster, the Liberal Democrat spokesman: 'If you think education is expensive, try ignorance.'

We could start by re-evaluating our very concept of education, giving proper consideration to what the arts have to offer in its effective delivery. At present, the teaching of my particular subject, dance, takes place within the Physical Education Curriculum. Its status as an art form is automatically negated, and the benefits of dance are reduced to good posture and the ability to differentiate between good toes and naughty toes. In Primary education, the only stage at which dance is a compulsory component of the syllabus, the emphasis is almost entirely on the development of physical skills. I am not against the physicality of dance providing a 'way in'. 'There has to be a hook, or the connection will not be made; the graft won't take'.[26] But the study of dance can provide more than a straight back and strong legs: for the artistic values inherent in dance to be of benefit, the pupil must move beyond

mere physicality. When the child reaches the age of 14, Physical Education in itself becomes optional. Even where it is selected, dance has a one in four chance of being a key element in the course. It is only at this stage that the programme of study at last makes reference to the 'communication of the artistic intention'.[27] The likelihood of the child taking dance as far as this, which is of course totally dependent upon dance being a subject which the school offers, seems rather slim. The likelihood of that child becoming a member of the audience for dance in later years seems even slimmer.

The report commissioned by the RSA on the effects of the National Curriculum on the teaching of the arts in our schools finds a 'growing disparity in the ability of schools to meet its minimum requirements'.[28] It reminds us that the minimum entitlement should be a starting-point rather than a target in itself, and warns that even the guaranteed level of provision is now out of reach for a sizeable number of pupils.

In the first lecture of this series Virginia Bottomley told us that 'creative and cultural education is vital for raising the rounded citizens of tomorrow'. If the National Curriculum is not delivering that education, just where do we expect it to come from? What sort of citizens can we expect?

It doesn't have to be this way. Earlier this year at the end of a long day of rehearsals, when all I wanted to do was go home and put my aching feet up, I dutifully fulfilled a long-standing commitment to visit a school in London's Tower Hamlets. However much I resent my deeply ingrained sense of duty, there are many occasions when I have reason to be very grateful that it is still there. What I saw that evening was the embodiment of everything I have said here. I came away humbled by the experience.

Mulberry School is an inner city girls' school tucked into a site behind Commercial Road. For those of you who aren't familiar with Tower Hamlets, I will simply say it is not Mayfair. A recent batch of graduates arrived at the school with only 8 out of 210 pupils in the top band of reading ability. They left, however, with

the highest number of GCSE passes in the borough. The school is unusual in that it has prioritised the arts. Both the head teacher and the governing body ensure that there is a commitment of staff time and resources so that the arts are not an extra, but the entitlement of every child in the school. Pupils at Mulberry must study all the art forms, and at GCSE they follow either an Expressive Arts course or Physical Education with dance as a key element. The school has witnessed the benefits that this emphasis on the arts brings to other areas of the curriculum. Further afield, *New Scientist* has reported similar findings in studies in Switzerland and the United States.

In recent years the Mulberry girls have enjoyed arts residencies with Emlyn Claid, Ricochet Dance Company, Théâtre de Complicité, Lindsay Butcher, The National Theatre and The Royal Ballet. Not a bad CV for a 16-year-old. I have worked with only one of that roster. They have developed and performed a version of *Romeo and Juliet*, the culmination of a project with The Royal Ballet – that so-called 'bastion of élitism'. Shobhana Jeyasingh was commissioned to choreograph *Answers from the Ocean* for a performance in Wapping Hydraulic Power Station. With The National Theatre and Lindsay Butcher they incorporated aerial circus skills into a production of *The Tempest*. The school maintains strong links between all its departments, and each of the projects combines elements of design, music, dance and drama.

The school sees the arts as a 'vital opportunity to experience the world through other people's eyes, and through other people's vision reach an understanding of that world'.[29] This belief underpins and visibly illuminates everything they do. I left the school with the words of Shakespeare ringing in my head: 'O, brave new world that has such people in't.'[30]

I also found the answer for the gentleman from Leeds in the words of a girl from that school in Tower Hamlets. She told us:

> When we heard that we would be hanging down from
> trapezes and flying on ropes, we thought 'no, this can't be
> done, it's just impossible'; and when we got to do it, it was

just so easy. We thought 'if we could do that, why can't we do anything in life?' It just really proves that to us.

How I wish you could have heard her say those words: 'If we could do that, why can't we do anything in life?'

References

1 Quoted in Hoggart, R. (1995) *The Way We Live Now*, London: Chatto & Windus.
2 Gowrie, Lord (1995) 'The Philosophy of Cultural Subsidy', First Arts Council Lecture, 9 January 1995, RSA: London.
3 Bland, A. (1976), *A History of Ballet and Dance*, London: Barrie & Jenkins.
4 *The Sunday Times*, 5 August 1996.
5 Arts Council (1996) *Facts about the Arts '96*, London: Arts Council.
6 Central Statistical Office News Release, 5 October 1994.
7 *Evening Standard*, 16 October 1996.
8 British Tourist Authority (1994) *The Overseas Visitor Survey*, London: British Tourist Authority.
9 O'Brien, J. and Feist, A. (1995) *Employment in the Arts and Cultural Industries – An Analysis of the 1991 Census*, London: Arts Council.
10 Feist, A. and Hutchinson, R. (1990) *Cultural Trends 1990: 5*, London: Policy Studies Institute.
11 Society of London Theatre/City University Data for 1995/96.
12 Hall, Sir E. (1996) 'In Defence of Genius', RSA lecture, 8 February 1996, London: RSA.
13 Trevelyan, G. M. (first published 1942), *English Social History*, London: Longman.
14 Best, D. N. (1985) 'Primary and secondary qualities: waiting for an educational Godot', *Oxford Review of Education*.
15 Forster, E. M. (1905), *Where Angels Fear to Tread*, London: Penguin paperback edition 1968.
16 Best, D. N. (1974) *Expression in Movement and the Arts*, London: Lepus Books.
17 Brinson, Dr P. (1989) 'The Role of Classical Ballet in Society Today', RSA lecture, 16 January 1989, London: RSA.
18 McFee, G. (1994) *The Concept of Dance in Education*, London: Routledge.
19 Brinson, Dr P. (1992) 'The Conscience of Dance', RSA lecture, 11 March 1992, London: RSA.
20 Archer, J. (1996) *Dance in Action Project Evaluation*, Dance in Action.
21 Holy Body Tattoo dance group unpublished report, Vancouver, Canada.
22 Brinson, Dr P. (1991) *Dance as Education: Towards a National Dance Culture*, Basingstoke: Falmer Press.

23 Office of Arts and Libraries 1980s leaflet, quoted by Richard Hoggart in *The Way We Live Now* – see reference 26.

24 Collingwood, R. G. (1938) *The Principles of Art*, Oxford: Clarendon Press.

25 *Today* programme, Radio 4.

26 A line from Hoggart, R. (1995) *The Way We Live Now*, London: Chatto & Windus, here used in a different context.

27 HMSO (January 1995) *Physical Education in the National Curriculum*, London: HMSO.

28 RSA (1995) *Guaranteeing an Entitlement to the Arts in Schools*, London: RSA in association with the Arts Council of England and the Gulbenkian Foundation.

29 Coldman, R. (director) (1995) *Arts Residency Work at Mulberry School*, video created by Mulberry School and the Education Inspectorate of the London Borough of Tower Hamlets.

30 Shakespeare, W. *The Tempest*.

Child warriors suspending disbelief with cardboard boxes: children have a right to develop their imaginative and artistic skills and to experience the social and psychological benefits that involvement in the arts can bring.

WHY YOUNG PEOPLE MUST HAVE THE ARTS

RUTH MACKENZIE, OBE

Executive Director, Nottingham Playhouse

I was on a platform a few years ago on the subject of the arts mattering and one speaker pointed out very acidly that you would expect a group of artists sitting on a platform to say that the arts mattered, since our livelihoods depended on that belief. We had a financial interest in believing in the arts. So I'm not going to talk much about the beliefs of those who work in the arts and already care about them. We are the converts: I get my salary from the arts and obviously they are the most important thing in my life and in the lives of all those in Nottingham with whom I work. I'm going to start by talking about some other people who would perhaps have less reason to believe that the arts matter, and, particularly, less reason to believe in professional artists working in education.

In the last few years in Nottingham we've worked with a variety of partners in the area of arts education. We've worked on projects about crime, AIDS, arson, drugs, bullying, the plight of the coalfields and the development of electrical skills. With this range of projects, all of which have been led by professional artists, our partnerships have been with, in the case of crime, the police and probation services, for AIDS and HIV the health authority, for arson the Fire Brigade, for drugs the Department for Education, for coalfields the Hamlyn Foundation, for electricity East Midlands Electricity. We've also worked on a variety of other projects.

When I talk about partnership what I firstly mean is money. All

those partners have enabled us to hire artists to work with young people in our communities. Why did they do this? There are two levels of answers. These projects fell into two basic categories. The first I would describe as remedial. In Nottinghamshire we had a problem with young people burning down schools. One of the responses of the Fire Brigade to this was to come to Nottingham Playhouse and to talk to us about what, together, we could do. We commissioned a writer, Mike Kelly, to write a good, serious play, *Pandora*, about the allure and attraction of fire. It was quite a difficult piece, which we took on tour to schools in Nottinghamshire. The Fire Brigade paid for that project, came to see the play and stayed to watch the young people's workshop on the themes of the play. They looked at the follow-up teachers' pack and they were very pleased. Since then there hasn't been a fire in a school in Nottinghamshire, though this raises debatable issues.

Another example of a remedial project is our partnership with East Midlands Electricity. They, in partnership with the city's Economic Development Unit, have been enabling us to train young unemployed people under a scheme called Creative Sparks. These young people work with us for a year, at the end of which they are trained electricians. This is a scheme that aims to get young unemployed people off the streets and into a profession.

The second category is preventive. This is a slightly different type of arts education project. While the Fire Brigade came to us after the event, these are examples of people looking ahead, trying to prevent mostly social problems. A good example is the HIV/AIDS project which we've been doing with two local health authorities. This is aimed at Primary School children, most of whom are unlikely to have encountered the risks that the project examines. It was led by a writer, a puppet-maker, a designer, a composer and a director. These professional artists spent a week in each school. They worked with young people who were themselves the actors and who developed a performance piece on the very tricky and complicated subjects relating to HIV and AIDS which they then presented to their peers. I went to see a couple of

these. The young people showed amazing courage in talking about difficult personal sexual issues, particularly as it was in front of their peers – the most difficult audience to engage with.

The work we've been doing with the Hamlyn Foundation looks at the difficulties facing young people in youth clubs in the coalfields area of Nottinghamshire – which used to have coalfields and now doesn't. For them the patterns of work that their parents and their grandparents knew and their community have been fragmented. Professional artists have again been developing the young people's own skills and ideas. One of the most important points is that in the many projects we've been doing in the coalfields, we haven't done a single workshop on what it is like to be in the coalfields. We've worked on African dance, Philippine folk theatre, themes of theatre and art from around the world, but we haven't yet returned to the particular problems of that community. Those young people are driven by wider and more imaginative, outward-going agendas.

A third example is the work we've been doing on crime. Again this is preventive work with children mostly of ten and eleven, designated 'at risk', so they are identified by a range of social agencies. Again they have been working with artists, developing their own drama, in this case doing a sort of theatre called forum theatre which pinches ideas from videos. Professional artists do a little bit of a play, then you rewind the 'video', as it were, and the young people take over parts in the play to try to change the scenario, in this case trying to stop the young person ending up in a secure children's home.

The final example, which is perhaps the most ambitious, is a partnership with Boots. Boots are based in Nottingham and, while most of their work is aimed at health and science, they have a need to invest in the future of the community in Nottingham. We have a three-year programme with them, developing ideas such as citizenship, again through art led by young people's creativity working with artists in tandem with the Playhouse and climaxing each year in a play on the main stage which looks at the themes of

citizenship. Actually, it's pretty hard to find a children's play that doesn't look at themes of citizenship.

The final examples are those projects that are both remedial and preventive. In a way, those are the ones that I find most interesting. One example is the drugs work we've been doing, which is a huge project with the Department for Education. It's called 'GEST [Grant for Educational Support and Training] Money' – special money for special projects, nationally advertised, for which local authorities bid. We've been outstandingly successful in Nottinghamshire in getting a very large chunk of money for drugs education which the Department for Education and our education authority have invested mainly in art. This is a huge range of projects with artists presenting their own work and developing the young people's work on the themes of drugs. It ranges from, again, Primary work to work with Secondary pupils and older young people who use drugs. It's a two-year programme of great intensity and it's interesting to think of what happens when that finishes. For two years we've been flooded with what we call drugs money. After that I'm not quite sure what happens to the children in Nottinghamshire.

The best example I have of a remedial and preventive programme is the work of Nottinghamshire Education Authority themselves. They are, I think, as a local authority, the best arts educators in the country, since the abolition of the Inner London Education Authority. They invest over £4 million in arts education and their partnership with us accounts for £500,000, so we are in a very real way indebted to them for most of the work that we do. They have a very simple vision which they describe as an entitlement curriculum. They believe that all children in Nottinghamshire have a right to develop their own artistic skills and that they have a right to do that with professional artists. This is a vision that we at Nottingham Playhouse profoundly believe in as well, so that we are all on a journey developing our arts skills. Some of us may end up being Peter Brook, some of us may not, but that journey is something that we all share.

Throughout Nottinghamshire, schools get access to artists in the daytime through the work of Nottingham Playhouse. There are ten sessions in the school day and they also have access to an eleventh session when they can develop their own arts skills. When they leave school there is a bit of a gap, so we created a partnership with Nottinghamshire again, the Next Stage – adult education. Now, once you are no longer in full-time education, you can come and develop your skills, still led by professional artists. We have over 1,000 students a term at the Next Stage and together with Nottinghamshire Education we work with 25,000 young people in schools a year. It's a big programme.

For me the great inspiration point of this programme is that, unlike all the other examples I've given you, this is revenue funding. It's a core commitment. It's led by the longest-standing Chairman of Education in the country and it provides a stability of arts provision which is, I think, unique in this country. *The Times Educational Supplement* described it as 'an Arts Utopia' and I don't think they exaggerate.

The Fire Brigade, the police and so on invest in arts education at one level for remedial or preventive reasons, to address particular issues, but that's not the full story. Of course it is the job of the Fire Brigade, for example, to try to prevent fires and to address a particular problem, but we need to dig a little deeper as to why all these agencies turn to artists to help them solve their problems. After all, it's real money that they're giving us.

The first and most obvious point is that all these people, all these agencies, believe that the arts are a civilising and empowering force. They believe that it is useful for everyone in the community to use the arts to develop their own skills, their own sense of identity, their own sense of self-awareness, and to address problems. The second reason is that developing arts skills can make you employable. Apparently two and a half per cent of the workforce in this country now work in the arts – that's 650,000 people. With an example like Creative Sparks there's a very clear reason: if you train people in arts skills they'll get jobs. Not a bad reason, in my book.

The most important reason, though, is about artists as problem-solvers, and I think it's important to confront this. It isn't something new. The Greeks turned to playwrights to help them solve difficult problems. Artists have always been drawn to look at the difficult things that sometimes we are not equipped to deal with. Art, through the ages, has always been a thing that you turn to for inspiration and for comfort, that you turn to to help you to address problems. It may not always be at the level of 'What do we do about schools burning down?' but I think that the artist as a problem-solver and facilitator, as a guide for all of us as artists to think about the things that perhaps we don't want to confront, is immensely important within our society. The artists that we have worked with on all these projects have been inspired. No-one has set the agenda for them other than to offer a topic. No-one has offered them the answers – and nobody could. Nobody has offered the young people the answers when they've addressed these complex issues.

Out of these issues has come some great art. One of our drugs projects that we did was written by Lin Coghlan, an established playwright, and directed by Rachel Feldberg. Thirty eight-year-olds sat in the back garden of a very ordinary house, right next to two professional actresses who were playing eight-year-olds, taking them through a story about how two eight-year-olds came to deal with the father of one of them who was suffering from alcohol abuse. After the play had finished – it was quite a tough piece – the children went through a workshop where they demonstrated almost complete recall of lines, moments, little glances, expressions. It was not in any way propagandist. It was an extremely subtle piece about human relationships and how you deal with pain and suffering and anger. I sat there weeping all the way through, which the children found very peculiar, but for them I do believe this was a very important experience and it was one of the best pieces of art that I have seen anywhere in the past three years.

So art is an empowering, skills-developing, civilising force, a means of enjoyment, and a way of solving problems. These are the

real reasons why all these non-arts agencies invest with Nottingham Playhouse in artists. What's happened? It was not always like this. My first job was in a company called Moving Parts which worked with young people (that's where I started in arts education). We toured round the country and played mostly in informal educational establishments like youth clubs and community centres. We didn't want to work with young people who had to be there; we wanted to work with young people who chose to be there. Obviously the young people enjoyed the work and a lot of them thought it was important, but I don't remember all these Establishment agencies flocking to book us. We worked jolly hard to get our bookings, from rogue youth leaders and slightly mad community centre people.

Of course, we believed that the work we were doing was of enormous importance, but we were more or less alone in believing that. I can recall only two occasions when, in the sense that I'm now describing, it was taken seriously by other people. One was in Blaby, where we were touring a piece called *The Empire Strikes Back* – all our pieces, I should explain, were commissioned by young people, except, obviously, for the first one I mentioned. *The Empire Strikes Back* was about nationalism. We timed it, we thought rather brilliantly, for the World Cup. Unfortunately we were wiped out of the World Cup, but very luckily, for the theme of the play at least, we invaded the Falklands. So it turned out to be a time when nationalism was high on the popular agenda. Blaby was a stronghold of the National Front in those days, and a member of the National Front, after one performance of this piece, tried to strangle me, which was a very violent response to the play. I tell the story still with some pride because I was rather thrilled that this man had been so affected by our piece.

The other occasion was in Chatham. This was during the wave of youth riots in the early Eighties, and there was a conspiracy theory that there was a group of agents provocateurs going round the country starting the riots. The local paper in Chatham decided that Moving Parts Theatre Company were the agents provocateurs.

Again, I can't help smiling. We weren't; we were very serious artists and very responsible people; but we were rather pleased to be accused of this. (Also, Chatham is about the worst place in the country you could possibly think of starting a riot.)

What's happened since the early Eighties? How has the position of arts educators changed? At one level some very obvious and well-rehearsed things have happened. That's the line of history that says that starting with the Greater London Council and followed by other luminous local authorities like Glasgow, Birmingham, Nottingham, almost every metropolitan authority, local politicians have seen the value of the arts to solve their problems. In doing so they have transformed the opportunities for artists, and particularly for artists who are willing to engage and share their creativity with communities. That's a well-known story and I'm not going to linger on it.

Something else happened at the same time. Over the past ten years the performing arts have become more and more clearly a model of that thing – 'community' – that we yearn for. We're hearing a lot about community and community values. In the performing arts you are dependent upon a team playing a lot of different roles, completely interlinked, and you need all of the team to be working together for the piece of art to happen. Second, you need an audience. When you come, as an audience, to experience a piece of art, you need each other – you are socialised by your mass experience. This experience would be different if there was only one of you, and it would be different again if any of you were different. These are old clichés about the performing arts, but there's a serious truth about the position of the live arts in a society that, as it fragments – as perhaps the traditional pillars that defined a community, like formal religion, formal political or social groupings and to some extent family groupings fragment – the role of the arts has become more and more important as a shaper, as a sign that we still are a community, that you can come together as a community and at the end of the evening or the schools workshop you leave transformed in some measure by that community experience.

A second interesting point about the arts, which for me has only crystallised recently, is their importance as a discipline. Within the context of a society where the points of discipline seem more and more problematic for all of us, the arts are very straightforwardly a model of something that you have to practise, that you have to work hard at, in order to get better. That's a very comforting thing, I think, for all of us who participate in the arts and for all of those in power who make decisions about opportunities in the arts.

A couple of years ago we started a relationship with an extraordinary French dancer, Kofi Koko, who has now worked in Nottingham three times. His first visit was to do a series of international master classes for professional artists but, as is the Nottingham way, we also asked him if he would do a week-long residency with young people who were mostly excluded from school – pretty tough inner-city young people mostly of African–Caribbean descent. In France there's very little arts education history compared to Britain, and Kofi has very little English. He had no idea of who these young people were, but he's an extraordinary and inspiring artist and he went into the week's residency, as he went into his week's master classes, with very high expectations. We all know, don't we, about low expectations and the problems of low expectations. Well, these young people had never worked so hard in their lives. They put in the most phenomenal hours developing their dance skills. They'd mostly done some dance work with us before with other artists, and at the end of the week's residency they had been drilled, they were exhausted, but they produced a technical level of work that was breathtaking. So the arts as discipline is another interesting model – an interesting opportunity for us in a society where discipline is becoming a key word.

The final reason why the arts have come into their own is that we're very cheap. A relatively small amount of money invested in the arts and in artists gets you a lot of extraordinary young people and extraordinary art.

I started off by wondering whether I needed to convert those of us that work in the arts. I didn't think I did. Instead I've talked about some of my partners in Nottingham whom I didn't need to convert either because they all came to us to set up work with artists in the community. I don't need to convert local politicians, private businesses, health authorities, statutory agencies in Nottingham, and I don't think we're that different from other cities round the country. So who is it that we need to convert about the importance of arts education?

I think the most important group are national politicians. It saddens me to say this, because almost all national politicians started in local politics and they all belong to political parties whose grass roots are alive and well in local government. Yet national politicians have a strange contempt for local government and have, to an alarming degree, persuaded opinion-formers that local government is a bad thing and is not the innovative model of local democracy that it is in many parts of the country. One of the difficulties we face with national politicians is that they live very strange lives. They live in no-man's-land in London; they work nights; they go back to their constituencies at the weekend, when normal life isn't happening. It's something we need to help them with.

It's a matter of very great seriousness that the arts have undeniably lost the national funding battle. Not only have we lost the battle; we haven't really even fought it. Everybody told us that the arts would be cut in the last Budget and those cuts are very serious for a lot of arts organisations up and down the country. More seriously, there's not a single political party that has the arts in its agenda in any serious way. I've spent some time describing the fabric of concern and work within the community of Nottingham and Nottinghamshire, led by our local authorities, but you see no reflection of that thought in the national election manifestos. The arts are scarcely mentioned and none of the work that I have described is mentioned at all.

Ten years ago Birmingham decided that the arts were so

important that they needed a central committee, led by the chief executive, on which the chairmen of Education, Leisure, Planning, Housing, Social Services, would all sit. This would be the way to begin to address some of the issues facing the communities of Birmingham. The result was a huge number of wonderful arts projects and arts facilities. That sort of thinking is nowhere on the national agenda, and I think it's the responsibility of all of us to see what we can do to change that.

We also need to look more deeply at ourselves. All of us are committed to arts education and believe it to be a good thing, but somehow, within the arts, we all marginalise it. It is still the case that arts education work in many organisations is on the fringes, dependent on project funding, the first thing to be cut; it gets the lowest prestige; it gets no acclaim often from the management or the board of organisations, it gets no publicity: it's invisible work. That's odd, if we care about it so much.

The other thing that concerns me is that we don't document arts work and we don't research it properly. I've been talking about arts education now for 16 years and for those 16 years I have been relying on anecdotes, about the moments of inspiration that I've come across seeing artists working within communities. All of us have reams and reams of anecdotal evidence. We all have the stories about the excluded boy who's now in the National Youth Theatre thanks to Kofi Koko's residency, and so on. What none of us has is hard research. None of us has any serious figures to give. How many artists working with how many young people in Britain over a year? What are the outputs? How many young unemployed people do an arts project and end up working in the arts? We don't know.

One of the projects that we're working on now is a 'hip-hopera' which will be performed by several hundred young people who are contributing to the research and development of this piece. It's inspired by street forms and funded by City Challenge and the European Social Fund. The European Social Fund demand hard outputs and I rather welcome that. So the hard outputs will be:

how many of those young people that created hip-hopera will go on to education or training in the arts – will then perhaps work in the arts? I think that's a good challenge for us and I'm ashamed that every time I fill in an application to the European Social Fund I'm making the information up. I think it's a scandal nationally that we don't have that information resource, that we haven't taken this work seriously enough to commission hard, proper, quantitative or qualitative research. We don't care enough about the outputs to get beyond the anecdote.

If we are to take arts education as seriously as Boots the Chemist, Nottinghamshire Fire Brigade, Nottinghamshire Education Authority, City Challenge and the European Social Fund, what should we do? This is my action list. Going back to the preventive model of arts education, we should be thinking at a national level about the role that arts education should play in pre-school education. This is the next area of policy development. It's the most logical area for provision of arts education and artists to begin. In preventive work we're already working with young people from five upwards. We at Nottingham are not yet doing anything with the three- and four-year-olds. We should be, and we're thinking about that now. We should all be thinking about that because it is something that national politicians are all thinking about. The issue of pre-school education and the role of artists there will, I predict, be one of the very important opportunities we could take over the next few years.

Most particularly, we should be thinking about the one in four children in our community who are on income support. That's three million children. Looking at the remedial arts work that we do, and indeed looking at the remedial work that we as a society do, if artists and arts organisations can begin to target those three million children, we know statistically that that is where the very cheap investment in the arts will have the best return in terms of developing a society of which we'll be proud.

We can't, though, abandon those that we didn't reach in their very early years. So on the remedial front my one tip is that we

should be looking, again at a national level, at the ways in which we can encourage the development of integrated youth policy. In Nottingham we're increasingly seeing agencies coming together in the way that I described, with the Birmingham departments, traditionally rivals, coming together to address the ways in which the arts would benefit all their areas. Young people are touched by education, leisure, training, planning, social services, probation services; and it's now becoming an exciting way forward for us at Nottingham Playhouse to sit down not just with those agencies separately but to look forward to sitting down with them as a group to say: 'What can we all do for young people in Nottingham?'

I believe that should be happening nationally and within the dream of an integrated youth policy. That really is quite a big cultural shift from the different segmented ministries, or different agencies looking after different bits of youth, as we have now. There are 100,000 16- to 17-year-olds now who are not in further education, not in school, not on a youth training programme, not in work. They must be our priority, surely. There are 600,000 young people under 25 who are unemployed. There are 650,000 of us working in the arts, so we could each mentor one. That's probably not the answer, but someone needs to take up this level of challenge as to what we do with those young people now – and tomorrow, perhaps, what we do with those pre-school kids and the one in four children on income support.

Finally, my big wish is that someone hearing or reading this lecture will commission some serious research on arts education, so that we all have some proper weapons to use in the lobbying of our national politicians. We should be taking ourselves and the work we do as seriously as all of our partners and funders take us. We should be believing in ourselves and in our power to transform society as much as the Nottinghamshire Fire Brigade believes in us.

One of the great lines in Nottingham Playhouse's three-year plan was written by Martin Duncan, our Artistic Director. We set ourselves some very modest targets, one of which was that at the end of the three years the word 'arty' should no longer be an insult.

In no other language that I can think of is the word 'arty' an insult. It is particular not even to the British but to the English that 'arty' is a derogatory term. Our other target was that for our communities in Nottingham and Nottinghamshire art should be as necessary to each and every member of the community as your daily cup of coffee is to waking up in the morning. That's what I believe arts education is. That's what we're aiming to do in Nottingham and what I want us to aim to do nationally.

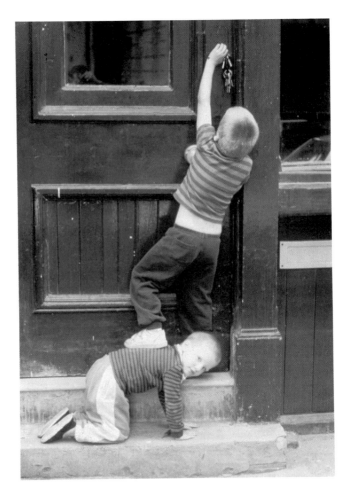

Good management gives people the space to aspire
upwards and helps others to solve their problems.
In business the arts can teach people that they can
grow, think for themselves and use the full potential
of their talents.

THE ARTS AND INDUSTRIAL COMPETITIVENESS

SIR ALAN COX, CBE

W hy talk about competition at all? What are the basic rules of competition? What are the ingredients of success? What part do the arts play in all these?

As an introduction, I want to say that I believe there are some serious issues in this country that must be addressed. I hope to be able to justify the view that we are at a serious disadvantage at this moment. In general the educational development of our people is not world class. The qualified engineering proportion of our population is too small. Most of the people who are in wonderful, delightful creative positions do not become entrepreneurs. Risk-taking in this country is seen as a good thing except when it goes wrong, when it can be tainted as slightly shameful. Most of all, and this is central to my thesis, we do not have enough people in this country who have an expectation of being creative and of being able to take responsibility. I hope that I can show you how that can be rectified over time with the great help of the arts.

There are many aspects of competition. We realise that real competitiveness comes from employees with educational skills who are creative as well as being well educated. We talk in this country about the need for a better educational system and, having been on the teachers' review body for four years, I fully understand that point. We talk about the fact that competition must be accompanied by low inflation. I have to tell you that our best competitors in the world for some time have had both these things (ordinary, everyday things): low inflation and high educational

standards. These are a given. What they do on top is to add creativity right through the whole of their workforce. This is what world-class competition is about. I believe this is what we have to address. It is an issue that is not talked about fully enough in my opinion.

If you are running manufacturing, and I am speaking as a manufacturer, one can learn one simple lesson from competitive analysis. If the people factor is not right in the company you can be sure that the other things won't be either. The quality, the cost, the use of other materials, the way the marketing goes and everything else will be affected. It is a fundamental point – obviously a truism – to suggest that if the people are not right no other aspect of the company will be right.

So why talk about competition? The following was written by a man who lived not far from the RSA, William Hood, to his boss, Sir Josiah John Guest, in 1816: 'Foreign iron: there's been a large quantity of Swedish iron exported to India in consequence of the bad quality of the British [iron] that has been exported for some years. And I think that British iron will run a great risk of losing that market.'

He was referring to the Dowlais Iron Works which at that stage was fast becoming the largest company in the world. ASW is a direct descendant of that company, which started in 1759. Competition has been around for a very long time. Mr. Hood was fast to point it out. This is why we need to talk about it and about the real issues we face.

In 1981 ASW had the privilege of working very closely with two companies in Japan: Kobe Steel and Kyoei Steel. We saw that they had excellence of an order of magnitude which was beyond the imagination of our top management. Indicators of their actual performance were 70 per cent above the level that the management we were employing expected to achieve even if we achieved all our potential. That is how far out we were, and it was a huge shock. ASW has managed to increase its productivity by 12 per cent per annum for 15 years and now has just about caught up.

This catching up was done through the realisation that the enormous difference was about people. It wasn't about technology, or money, or market shares, it was about people. We saw that people at all levels in these companies had learned to look for the fine detail in order to improve. We learned that they operated within some main themes, elegant themes, day by day. We learned that they were people who were looking for improvement the whole time, every day, and that, once they had improved, they started to search again for the next level of improvement, removing one bottle-neck after another. These were people who respected each other's ability to be creative and to take responsibility. These are cultural matters, they are not simply issues between the boss and the employee. This is the fundamental competitive point I hope to make.

I believe that in our lives the arts can play an important part in helping people to grow. I hope at least to persuade you that the arts have a very important role to play in helping people to have the expectation that they can take responsibility and be more creative themselves.

Of course deficiencies in education and other factors can be dealt with and discussed in many other wider areas of social life. I intend to direct discussion purely at the immediate consequences of direct competition on an industrial basis. It is a cliché to say that competition is growing everywhere. It is moving faster geographically, it's moving in production, it's moving in innovation, it's forcing change, it's bringing surprises, it's increasing turbulence. It is a change of quantity and location in growing markets. This change in competition is not happening in declining markets. Competition has fewer barriers to overcome today than it used to have. Previously, in order to sell steel in many countries, you had to prove your steel could work in each place. This could, and still can, take years, but the time required is reducing fast.

The global market is not a cliché: groups are spreading their markets. The reasons are clear: a market share reduces costs and this influences prices. The same thing is happening in services in the

City. It is happening in engineering products. Globalisation has had a vast effect on many industries. It is forcing people to reorganise and to have different management outlooks. Industry needs positive cash flows all the time and the financial criteria across the world are not the same. Some countries are used to living with low inflation. The return which they require is different from others. For some companies there will be no safety margins, if they believe that high margins are automatically a thing of the future. There will be no room for the high cost producer. In the old text books of Harvard we read that the high cost producers are the people who set the selling price. Those days have gone. The pace-setters now are the people who demonstrate ability in all aspects of running their business.

We have, of course, in the UK, many brilliantly-run, competitive, worldwide businesses, but their performance should not obscure the fact that manufacturing performance overall is in deficit. Japan has had a positive track record. Germany has a healthy balance of payments in manufacturing while the USA has had a continual deficit with some steady improvement.

Coming to the question of gross national product, starting in 1963 ending in 1993, Britain was some 30 per cent below that of Germany and France. This was in an era of decline in the exchange rate of the pound. The Deutschmark was strong against the pound during the same period.

This was written in *The Economist* on 6 June 1962, when the exchange rate to the pound was 11.8DM, but you could have read something like it yesterday:

> One can certainly reckon on an increase in the volume of British exports this year. It is surprising that this has not shown up before and it does appear that British exporters are competing rather more effectively with those of Germany where even apart from the effects of revaluation there has been a rise in export prices following upon a large increase in wages.

In this *Economist* the yen is not even quoted!

What has happened since? There are many theories about this gap and why it has happened. I will deal with the period during which I have been working, with today and what I see as best practice through my own detailed knowledge of a number of companies on a world market basis.

To suggest that low inflation and education are going to sort the gap out is not correct. As I have already said, better education is certainly required. We are attracting investment in the UK. Some people argue that this is a wonderful thing. I certainly do. One could ask why other countries don't do so well. We ought to be asking whether they need to do so well. Certainly we are now seen as a country in which to invest because we have productivity, we have low inflation and we have these developing skills. But if you visit Lombardy or parts of Germany you can see thousands of small manufacturing businesses and entrepreneurial spirit. They make machines to make socks for anywhere in the world, they make machines to wash up glasses behind the bars of the world. They go dashing around in all sorts of ways, taking quick decisions, developing new businesses, all the time. The gap we have is that we do not appear, generally, to be creative enough in two areas: having continuous improvement in existing businesses fast enough to match the best; and, secondly, having enough ideas to invent new products and to compete in world markets.

If we had a group of industrialists who wrote down what they thought were the basic rules of competition, I think they would probably say 'making sure that businesses can see the individual income and cost positions of parts of the business directly enough to make sure they are under control and they can face the competition clearly'. They would be a producer with low costs and they can keep that going and they can keep staying in that position through self-appraisal and continuous improvement. That's a way to achieve success.

How can we sustain competitive success? You can be continuously developing world-class products and the high cost of

investment may deter new competitors. Some businesses succeed by having high employment costs coupled with low investment but they also have outstanding products. If you look at some of the ratings of companies across the world, you will find there are a number who have wonderful products but these do not require major investment. They do, however, require a lot of skilled labour and a lot of brain power.

Continuous productivity improves by removing bottle-necks. Total manufacturing flexibility is required so that very small batches can be made at the same cost as vast batches. The change of attitude is to the delivery to customers; the speed at which things can be done and the quality of the product which you provide. These are fundamental rules of the game.

There may be differences in financial systems which enable one competitor to do better than another, but it doesn't seem that a strong currency is any hindrance to success, judging by the facts examined over a long period of time and it doesn't matter whether you have got a minority language or not. It isn't the fact that the world speaks German and Japanese which enables these countries to achieve the success they do!

None of these rules can be ignored, but I think they are bread and butter to the best companies. These are not insights; they are simply statements which enable me to argue that they are back-ups to strategy and determined action. They are the basic rules not the basic ingredients of success.

So what are the specific basic ingredients of success? What do they appear to look like? There are a number of points here which I would like to stress. A definite ingredient of success is to be able to give the customer increasingly high expectations – not the customer driving you but you driving the customer's expectations. What is needed is high and consistent quality plus reduced cost to the customer. It is necessary in this changing world to have high speed, integrated systems and personal contact in the supply chain. We must have very, very fast decision-taking, very fast responses. We need to provide more and more value by widening the scope of

the product and to have continuous improvement of at least 2 per cent per annum having taken inflation into account. The best companies in the world are probably moving far faster in everything they do: they have total flexibility of thinking and a combination of strategies for winning customers. Organisations look flat: the management cadre is disappearing in the best organisations. The simple reason is that other people in the organisation are now picking up responsibility. This is the most important point for industrial, sustainable competitiveness: how people spend their time. In the best companies 90 per cent of the management (call it the top 3 per cent of their people), spend 90 per cent of their time thinking about projects which will have an effect in more than 18 months' time.

It is important to concentrate on that point. The implications, which ASW learned from the Japanese in 1981, are enormous. It means that other people in the company have to take responsibility in terms of management. You cannot have the managers in the best companies going round checking on yesterday's performance and saying what are you doing about it? This sharing of responsibility is happening automatically in the best companies. There is no inertia, there is no delay in implementing change. Change is monitored and recorded because processes must be controlled but it is done as part of the normal system. Everyone is working to the same ethos, the same mission. Everybody is allowed to say: 'You are wasting my time'.

Management is an enabling resource in the best companies not a directing resource. Managers have very little time to direct. They should be thinking about the future because that's what their competitors are doing. They are looking at the long-term future and everybody in the company is empowered to bring about change. If you can imagine a supply chain where one company after the next supply each other and all have the same attitude that is competitive power of an enormous strength. The interesting thing is that it is not yet, as far as I'm aware, that common in the UK. How might we make it so?

Of course, it's very easy to say that what you have to do is to employ people who can take responsibility. They have the self-confidence and the expectation so that I can say 'Over to you. Tomorrow morning I am going to work on things of a long-term nature. Please continue to run this process. Please continue to speed up the decision-taking response to the customers. Please continue to reduce the stocks. Please continue to improve the process. Please continue to reduce the costs.'

It is what the best people do, but you need to have people all through the whole company who can do that as a matter of course. It must be coupled with honesty and openness. I don't mean honesty about cheating in any way, but the honesty of being frank and letting the truth emerge as to what is actually happening in the process. This poses an enormous challenge. It is not a question of levels of education or of low inflation, it is a question of mobilising the total talent that is there in any business.

How do we get there? These people cannot be invented. The problem is inertia. The problem is that people do not believe they can have these expectations and this is the great thing that must change. You can have the highest calibre of graduates working in teams and yet they will not feel they are responsible enough to take decisions unless they are empowered to do so. Even then it is not an easy thing to achieve. It requires an ethos, it needs training and it needs enormous and continuous resources to persuade people that they can actually take this bold step. It entails risk. The management has got to be lifted to a different level. Management has to be barred from dealing with day-to-day concerns. By example people can be given the space to aspire upwards.

How do we give people the courage to rise into that space? The first step is easy enough: make the management move up and understand how it should use its time. The next step is to convince everyone else that they can move up too. But we are still not giving people space to be creative on a world-class basis. It's a space that the world-class companies have understood and have given their people – and they have taken to it. Management in the best companies

helps others to solve their problems. This is the model of enabling management. They are there to help people when they have difficulty in solving a problem. They demonstrate to others how to work in groups. They value other people's ideas and empower them to take action to improve things, to challenge inertia wherever it exists – empowering them to realise their full personality.

I have met a lot of people who are great personalities when they are out in Splott (an area of Cardiff) but not when they come into work in a department in the steel works. In the factory titles don't mean anything, and personality means everything. People must be freed up to give full vent to their personality. Giving them the training is one way.

My thesis is that this is an area in which we can use the rich talents of people working in the arts. The arts teach people that they can grow, think for themselves, see ways of using their talents in the workplace directly. People need help and, in the arts, there are talented people who know exactly what creativity is all about. I see the arts as being able to place themselves centrally in this argument. I am not saying the arts provide the only answer, but it is an industry in which enormous creative talent exists and it can play a significant role in helping industry to get to world-class performance.

Here are some specific suggestions where art involvement can help. Getting people to speak about what they have learned is always difficult. There are plenty of people who will sit in an audience and pretend to learn. The worst thing is to be in the audience on a course and then have to make a speech about what you have learned – learner-led learning. Actors can do a superb job in helping people go through that rather inhibiting process.

Both productivity and pride can be affected by groups within the workforce being aware that their company and colleagues are involved in community arts projects. Being involved in it themselves helps employees to have an awareness of how people work together in the community as well as in the workplace. Encouraging the employees to become involved in creative

community work, even if it is only in pieces of art which stay in the streets of the area in which they work, is another important way of going about this. By working on community arts projects people become aware that they can actually be creative in groups. The workplace is part of the community and people recognise that this creativity can also be applied in their day-to-day work.

Working on different types of project together, not just outward bound but arts experiences, singing in a community opera, helping to build a steel viewing platform in a forest which is part of a public art project can give people new experiences, which helps to show that they have got much more creative potential than they realised. Role-playing is a very important part of life in industry. Role-playing about how the competitors feel, role-playing about attitudes of customers are all part of a process in which the arts can help to free people and enable them to understand other people's points of view.

Working on arts projects can enable people to see they shouldn't waste each other's time. Taking people out of their own environment, or bringing them into an environment where people see things differently, helps to redefine the ethos of the company and brings the realisation that the company is part of a bigger world. It also underlines the fact that the company is serious about trying to help people to realise their full creative potential.

Some will say that this is very fanciful, this idea of bringing people in the arts into industry. Of course, there are many other ways of tackling the problem but my challenge is 'let's list them, let's talk about them.' If I am right and world-class companies have adopted new policies through cultural means in order to bring to light the full potential of all their employees then we have no choice but to use all the resources we can to help us get there. Thus we will ensure that change is continuous and that ideas are coming (no matter out of whose mouth) for continuous improvement. It's a choice that could be adopted by people getting together with the arts and companies in their local areas to start some mobilisation with small entrepreneurs.

One of the problems for a small entrepreneur making things in the UK is that they quickly run out of people to delegate to. I've met one after another where suddenly the good idea becomes paralysed by the fact that the man has to make sure that everything is done properly by himself. It's trying to get under the skin to help people to grow that will secure successful businesses. It might be having artists in residence, or using actors in training programmes, or employing composers to work on music projects. It might be a large-scale opera project in the local community. All these things have been tried and do work.

Actors can help to show people what engineering is about in schools. We have engineers talking about engineering in schools. Most of them aren't entrepreneurs and most of them are salaried but most of them don't think about involvement in projects which will happen in more than 12 months' time.

This does not need a change in management attitude. People need help to realise their full potential. This is not just a question of a management seminar.

The best British companies who lead the world, who are driving on through the world, are quite capable of facing this task. My key argument is about the overall expectations of people. How they can be empowered to help bring about change and innovation themselves. How can millions of people – because that's what we're facing – continue to grow personally? This is obviously an ingredient for happiness and for wealth creation. It is hard to imagine growing business without people in it also growing personally. That is an equation that simply can't happen.

If you want to grow your business without ensuring the growth of individual people within the company then you are deluding yourselves. The world-class companies that I've seen actually manage to become world-class because they are growing their people faster than they are growing their company. The challenge is to create a background not just of a far more educated population which rightly and naturally believes it should be able to take responsibility. We certainly have a big backlog in education: that is

incontrovertible and everybody recognises this, but we must keep moving forward.

I think the arts offer rich and varied talents. They can show us what we are, they give us a vision of what can be and how we do it. The arts can play an enormous part in showing people that they can be creative and can change the workplace on a comprehensive basis, if we allow them and encourage them to do so.

'Army trees', or, officially, 'plane trees'. The unofficial
education of the arts teaches us not to be over-
impressed by the facts of life and adults' official,
common-sense interpretation of our shared world
which ensures that we all know where we are.

THE UNOFFICIAL EDUCATION
OF ART

ADAM PHILLIPS

Psychotherapist and author

It is part of virtually everyone's official education to be taught what we call euphemistically 'the facts of life'. Most children, of course, learn these facts both unofficially – in the extravagant inventions and mischievous jokes of their peers – and officially, in more technical language, from adults. But there is, as everyone soon realises, some puzzling difference – some odd disparity – between the biology of reproduction, and what adults call sexual or romantic fantasy. Biological facts and erotic daydreams are uneasy bedfellows, so to speak. We teach the facts of life in school but we don't think of educating our children in sexual fantasy; though if we were the crudest of Freudians we would say that we do educate our children in sexual fantasy – we do teach them about erotic life – but we call it, among other things, the arts. It is, I think, interesting to be able to be the crudest of Freudians; but it is not sufficient.

Freud himself, whose writing is often artful, incisive, lucid, was an artist who wanted to be a scientist. Indeed, he was, in a sense, the least crude of Freudians partly because he was so attentive to the complexity of the relationship between the artist and the scientist – both within himself and in the wider culture. But it was, oddly enough, the child's sexual curiosity – the way children do and don't learn the facts of life – that was for him the key to this ongoing argument between science and the arts; and so to what I am calling the unofficial education of art.

The biological facts of life are official knowledge. They are clearly, in an intelligible sense of the word, true. Anyone who didn't take them seriously, anyone who refused to acknowledge these facts, could find themselves in serious trouble. And yet children, Freud realised, can live as though these so-called facts are irrelevant. Indeed telling children the facts of life has, Freud writes, the oddest effect: 'After such enlightenment', he writes,

> children know something that they did not know before, but they make no use of the new knowledge that has been presented to them. We come to see that they are not even in so great a hurry to sacrifice for this new knowledge the sexual theories which might be described as a natural growth and which they have constructed in harmony with, and dependence on, their imperfect libidinal organisation (sexual development) – theories about the part played by the stork, about the nature of sexual intercourse and about the way in which babies are made.[1]

In other words, after receiving this essential knowledge, children go on behaving as though they knew better: that babies really are made by kissing, and so on. They, at least to some extent, refuse the adult's authority, and resist whole-heartedly accepting their scientific knowledge. And Freud comes up with a revealing analogy for this: 'For a long time after being given sexual enlightenment', he writes, 'they behave like primitive races who have had Christianity thrust upon them and who continue to worship their idols in secret'[1]. It is, Freud implies, like a choice between two religions, and the children refuse to convert; their own sexual theories – or fantasies as we might call them – are like idols they cannot relinquish. Children, in Freud's story, grow up in the crossfire between a religion of fact and a religion of fantasy. Encouraged, quite rightly, to be realistic – to accept the facts and live by them – children, we cannot help but notice, are full of the most imaginative wishes, the most unlikely stories. Little children – as everyone who spends time with them knows to their cost – live

as though if you want something you can have it. This is not exactly a scientific view of the world.

In Freud's story children are, as it were, born artists trying and trying not to be scientists: both needing to comply with reality in order to survive and trying not to – finding ways round. Our perceptions are informed by wishes. Children want to make the world better for themselves – more of a piece with what matters to them most. So they construct what Freud calls their sexual theories – their stories about where babies come from, what the differences are between men and women, what relationships are made of – out of their own needs and desires. They don't, in Freud's view, ignore what we call reality, they just use it for their own purposes. Children are not exactly what we might call empiricist; they simply use so-called real things as food for thought, to dream with, to make up their own stories about which they are passionate. 'These false sexual theories' of children, Freud writes,

> have one very curious characteristic. Although they go
> astray in a grotesque fashion, yet each one of them contains
> a fragment of real truth; and in this they are analogous to
> the attempts of adults, which are looked at as strokes of
> genius, at solving the problems of the universe which are
> too hard for human comprehension.[2]

Children make something of their own from what they are given, but that something of their own is something quite idiosyncratic, something peculiarly personal. The child's theory about sex may go astray in a grotesque fashion – babies are not made by kissing; and yet the theory contains a fragment of real truth, kissing is often the prelude to something men and women can do together. It is clearly not incidental that Freud likens this intensely imaginative, truly fantastic childhood project to what he calls adults' strokes of genius by which they solve the problems of the universe. Religion, and modern science, he intimates, are akin – more similar than we might like to think – to the enterprises of childhood. What the artist and the scientist and the religious believer may all share –

apart from the fact that they were all once children – is the wish to make the kind of meaning that will sustain their love of life.

From one psychoanalytic point of view children – and the adults they will become – are essentially dreamers. You may all come to a lecture with some kind of shared purpose; bits of the lecture may even strike you as interesting, and make you think. But that night you may dream of the earrings of the woman who was sitting next to you, or of the colour of the lecturer's shirt, or the door of the lecture room. In other words, it is as if there was someone else inside us, with quite different interests, picking up something else out of this occasion to be used for dreaming. And any one of my words, or phrases, might set off a whole range of unexpected personal associations or memories. There will, in other words, be an inevitable and interesting gap between what I want to tell you, and what each person might make of it. Each of us is, in a sense, involved in (or reading) a different lecture.

This is what Freud means by dream-work, by the sexual theories of children; and what might still, simply, be called imagination. It is a process of transformation: of the freedom to make something of one's own – according to one's needs – of what one finds or is given, and the sense in which one never quite knows where it comes from, or quite why one makes what one does of what happens. Psychoanalysis itself is a story – one among many competing stories – about how we transform our experience; about how we make, or fail to make the kind of meaning that makes our lives seem worth living – that gives us something to look forward to.

All this has been rather a roundabout way of getting to a question that I want to consider. What does psychoanalysis have to say – or rather add – to our assumption that the arts matter? This is an assumption, of course, that brings with it more pragmatic questions both about why the arts might matter and what they do for us that we value. So what kind of case can one make, from a psychoanalytic point of view, about the importance of the arts in education? And at a time spellbound by cost benefit analysis, and the exorbitant ambitions of technology.

Perhaps one of the most telling things about the Arts versus Science debate in education is the ease with which it collapses into cliché – into familiar polarised oppositions: artists as passionate, reckless dreamers, and scientists, as cold, detached controllers – when it is clearly the case that all sorts of people are drawn to both, and that neither need be demonised. Both the arts and the sciences are forms of curiosity; both often have their source in a sense of wonder and amazement about the world; both have unpredictable consequences for the people who value them or believe in them; and both make useful kinds of meaning out of experience. And neither of them, of course, have a monopoly on passion or imagination. Nor indeed, do either of these overused terms do more than vaguely gesture towards a broad range of diverse social practices. And yet the fact that something we go on calling 'the arts' needs defending, or justifying, tells us something about what the arts may be up against. What are we defending when we defend the arts? It is such a difficult question to talk about because the arts are often self-evidently valuable for those who value them. I think it is possible that one of the reasons psychoanalysis turned up when and where it did – in Vienna at the turn of the century – was to be a site, or a setting, for this apparent conflict between the arts and the sciences; which is also, in the terms in which I'm speaking, the conflict inside each one of us between the dreamer and the realist.

From a psychoanalytic point of view, what we are defending when we defend the arts is the value and significance – the form and the function – of fantasy in each person's life. Not fantasy as merely an alternative to, or refuge from, reality – though it can of course be used as escapism – but fantasy as the means or medium through which we engage with reality. We are continually – whether we are conscious of it or not – telling ourselves and other people stories about what is happening, and about what hasn't happened: about our hopes and our disappointments. We are forever interpreting and redescribing our experiences – reliving past experience in terms of present experience and present experience in terms of past experience. Whether we are involved in the arts of

daydreaming or night-dreaming, it is clear that we are full of thoughts; indeed, as psychoanalysis would suggest, we are virtually lost in thought (and feeling). One of the most obvious things about these fantasies – these stories we tell ourselves – is that they are not necessarily congruent with the way things are. Like the children's sexual theories, and indeed dreams, they often seem to be at odds with reality – not obviously part of the shared world we like to take for granted. They are at once peculiarly meaningful and difficult to make articulate sense of (like works of art). In Freud's view, we are the animals that are excessively imaginative, truly fantastic in our expectations and anticipations, and expecting the earth of each other.

One dictionary of psychoanalysis defines fantasy as: 'An imaginary scene in which the subject is a protagonist, representing the fulfilment of a wish (in the last analysis an unconscious wish) in a manner that is distorted to a greater or lesser extent by defensive processes'. What this means in ordinary language is that a fantasy is an imaginary scene, or story, in which we cast ourselves as the hero or heroine. This story involves satisfying our wishes: they are success stories. But – and this is the less obvious, psychoanalytic point – we have to conceal and disguise our real wishes because they are unacceptable to us. It is – to use Freud's most famous cliché – safe and exciting for me to imagine meeting the woman of my dreams; it is rather more complicated for me to realise that this could be my mother. So from a psychoanalytic point of view fantasies are stories – disguised stories – about what we want, about what matters most to us; they are disguised because what matters most to us can be quite unacceptable to us; or at least full of conflict. I may want to be successful, but my success may entail other people's failure or envy, or my own greed. So I want it and, in another part of my mind, I don't want it. Fantasies, in other words, are also always the battleground of moral conflict. There is no pleasure without justice; and no justice without pleasure. The differences may be rather obvious, but the most banal daydream – like any Greek tragedy – is an ethical contest about how we want to

live and who we want to be: about what matters most to us; and what the consequences are of such things – like love or honour or justice – mattering so much to us. To take fantasy seriously – not earnestly – is to have the opportunity to consider our values in relation to our pleasures. Which is, of course, what we do in art, and in political life.

What psychoanalysis brings to all this is what sounds like a silly question: what is the significance of the fact that every politician, and artist and scientist – every adult – was once a baby? That one way or another they had two parents, who had parents themselves; that they became children and adolescents in an articulate group of people and acquired thereby what we call a personal history. It is, of course, one of the defining characteristics of the modern world that we have made childhood matter and in very specific ways. We think now of people evolving, developing and growing over time; both in terms of biological and cultural competence. We don't have to be sentimental about babies or small children to acknowledge that for better or worse, this is where everyone starts. There is no cure for this. Everyone, over time, comes to be who they are. I suggest that, in a peculiar sense, in defending the arts (in education) we may – at least now – be defending the importance to each person of their very specific personal and transgenerational history: and that this has something to do with the development of fantasy in the child's life – of the ways in which the child makes a personal history out of a biological and cultural inheritance. I suggest that what we call the arts may be particularly, if not exclusively, well suited to the child's learning to feel and think and speak without fear of punishment – at least without too much fear of punishment; without over-accommodation, without excessive compliance, without an eagerness to submit to the way the world is supposed to be.

The arts teach us not to be over-impressed by the facts of life. Children can be made fearful, or simply be intimidated by seeing things in their own way or doing things in their own time; despite the facts, despite all the official versions of the way the world is.

One of the useful stories psychoanalysis tells us is about the inevitability – and the cost of – complying with the culture we are born into. No-one chooses their family, their language or their culture of origin; and yet despite all this necessary adaptation each person innovates out of the traditions they are born to. In modern societies one of our best pictures of this is the distinctiveness of each artist's style. Picasso and Stravinsky and Auden didn't invent painting or music or poetry, but they did something different with them. They made something of their own out of their inheritance.

So we might think of the arts as protecting and sustaining an important paradox: that a person's experiences and expression can be both unique and shareable; distinctive and recognisable. If I ask you the stark question 'what is sex?', you could tell me the more or less shareable biological facts of life. Or you could wonder – less shareably, and with more difficulty – what sexuality is for you personally; how – if at all – does it seem to fit, or fit in with, other areas of your life? What do you use sex for, or think of it being like? It is in the arts, I think, that we can get the more personal, the more nuanced answers to these questions. And then the more personal questions. What we call the arts, in other words, are well placed to speak up for whatever might be valuable without necessarily being consensual; for what might be personally significant without being wholly or obviously shareable (and sexuality in this context may simply represent whatever is most resistant to, and requiring of articulation).

Psychoanalysis, if it is about anything, is about the cost for each person of acquiring their culture: what Freud called 'Civilisation and its Discontents', implying in his title that if the two are not inevitably twinned, they are often linked. The question for each person – to which his or her own development or life story is the answer – is whether they can use the culture they inherit to sustain the personal meaning of their lives; to what extent it helps or hinders them in their love of life. Culture, of course, starts at home, and then widens out into the world of school; and schools and homes exist within the pressure – the force field – of the

surrounding culture. In order to participate – to become, as it were, a fully paid up member of one's own society – one has to learn certain rules and conventions. We soon learn, for example, that when someone points we look at what they are pointing at, we don't look up their arm. We learn how to speak to the people we need to speak to; how to behave properly, without too much shame, and so on. Yet, as with my earlier example of the facts of life, it is as if we have an official and an unofficial education (learning the rules is learning what it is to break them). We are, as children (and indeed adults) forever being told the actual or the metaphorical facts of life; stories about the way the world is, which often means stories about how some group of people think the world ought to be. We are always being persuaded that something is a fact and facts of life easily turn into collusive assumptions that protect people from thinking their own thoughts. It is, for example, a topical fact of life that what children and adults need to do is to return to family values. We can all nod our approval, spellbound and bonded together by the slogan; or we might wonder which families are being referred to by this phrase; and what if anything do we value about family life; and how come there are apparently so few alternatives to the nuclear family; and whether the casualties of the family – those people for whom the family hasn't worked – are telling us something rather important; and whether this fervent insistence on the family isn't itself a way of managing an enormous amount of doubt about it. The official education of our children may, in the near future, entail them learning family values. Hopefully their unofficial education – to which the arts are well suited – may enable them to think and talk otherwise; if need be, against the current. That is, to talk about the family without fear of punishment.

There is, of course, nothing intrinsically anti-conformist about the arts, nor should there be. And yet what spaces are there in culture for the things that might matter to people to be considered? – for people to find their own places in the argument. The arts must be as subject to ideological and economic constraints as any

other social practices. But reading a novel about the family – and what novel isn't about the family? – tells you, or, rather, shows you, something different from reading a political polemic on the importance of the family, or indeed a good book called *Sanity, Madness and the Family*. A child reading *Alice in Wonderland* is getting a very different sense of what girls might be like than he or she would from reading *The New Testament*.

It is this difference that I am calling the unofficial education of art – that the psychoanalyst Marion Milner describes in her wonderful and aptly titled book, *On Not Being Able to Paint* – a book, in other words, about most of us. Milner discovered for herself a technique that she called 'free drawing' because she thought of it as akin to free association, which patients are supposed to do in psychoanalysis. Instead of saying or writing whatever came into her head, she found herself, as lots of us do in apparently idle moments just doodling – doing random, unintended little drawings, not necessarily of anything in particular. Just doodles. But she noticed that there was an interesting and revealing process going on in this apparently rather trivial activity; an activity one usually finds oneself engaged in when one is supposed to be attending to something else – usually something more important. What most people do idly Marion Milner tried to attend to and use in the service of discovering something unexpected about herself. 'One thing I noticed about certain of my free drawings', she writes,

> was that they were somehow bogus and demanded to be torn up as soon as made. They were the kind in which a scribble turned into a recognisable object too soon, as it were; the lines drawn would suggest some object and at once I would develop them to make it look like that object. It seemed almost as if, at these moments, one could not bear the chaos and uncertainty about what was emerging long enough, as if one had to turn the scribble into some recognisable whole when in fact the thought or mood seeking expression had not yet reached that stage. And the

result was a sense of false certainty, a compulsive and deceptive sanity, a tyrannical victory of the common sense view which always sees objects as objects, but at the cost of something else that was seeking recognition, something more to do with imaginative than common sense reality.[3]

I want to draw out some of the interesting links and assumptions that Milner is making in this quite remarkable paragraph. What I am calling our 'official education', Milner calls turning her scribble 'into a recognisable object too soon, as it were'. If you want to turn sex into a recognisable object too soon, you describe the facts of life. If you want to turn the family into a recognisable object too soon, you start talking about family values. It is this notion of making an object recognisable 'too soon' that I want to draw your attention to. Like a pre-emptive strike against what Milner calls 'chaos and uncertainty' our official education enables us to take flight into consensus; into an apparently shared world of recognisable and familiar objects. A world in which we know where we are because everyone agrees with us. For Milner the art of this free drawing – the unofficial education she is acquiring – is in not taking refuge too eagerly in the recognisable object. The recognisable object is essentially unsurprising and puts a quick end to risk-taking. Almost like a phobia it is as if, at the moment she describes so well, she needs to make a fast exit, to get out of, to finish with the drawing as quickly as possible. And the result of turning these scribbles into something easily recognisable is a certain dismay; a sense of pointlessness and futility. 'The result was a sense of false certainty', she writes, 'a compulsive and deceptive sanity, a tyrannical victory of the common sense view which always sees the objects as objects, but at the cost of something else that was seeking recognition, something more to do with imaginative than common sense reality.' She had agreed with something – complied with something – without letting herself think it through or work itself out in its own way.

Clearly the pressures both inside us and outside us to turn our

thoughts and feelings into reassuringly familiar formulations – into the consoling clichés of everyday life – are great; and often difficult to discern. Allowing what Milner calls the 'thought or mood seeking expression' sufficient time to emerge entails bearing chaos and uncertainty; it involves feeling temporarily lost, or unsure of oneself. The risk is that our official education, for a variety of reasons, cannot give each person time to, as it were, draw their own conclusions. To defend the arts in education is to protect both each person's relative freedom to make something of their own, of what Marion Milner calls 'something more to do with imaginative than common sense reality'. The arts provide a space for imaginative reality which is always under threat from common sense reality. In this obviously post-Romantic view of the arts, the arts are essentially revisionary, renovating so-called common sense with each individual person's vision: fantasies of life continually redescribing the facts of life. And psychoanalysis itself – in the version of it that I value – continues the work of the first generation of Romantic poets, Blake, Wordsworth and Coleridge, for whom the child's vision – the child's imaginative reach – was a figure for the inspiration of the artist: the child as father and mother to the man.

Once again we find ourselves with two apparently contrasting terms on our hands: not fact and fantasy, not art and science, but imaginative and common sense reality. By promoting the value of imaginative reality, Milner is speaking up for the possibility of new experience; for the unanticipated, the surprising, even the anomalous. Like Ezra Pound, who once defined poetry as 'news that stays news' Milner is talking about what we might need to break the bounds of common sense or at least to explore the boundaries between common sense and imagination. Could we bear it if all our news stayed news?

Allowing ourselves the shock of the new involves, Milner suggests, 'bearing chaos and uncertainty'. It involves tolerating a conflict without too hurriedly resolving it. And it is perhaps interesting that in standing up for the arts, and in particular, the art

of the unexpected, she also finds herself speaking up for taking her time (making time for time, as the Jewish proverb says). Art or imagination is not here opposed to science, but to hurry. Hurrying, Milner intimates – making our objects quickly and reassuringly recognisable – is prompted by fear: the fear of stepping outside the known world; the need to jump to a conclusion to avoid a new beginning. New moods or thoughts seeking expression, as Milner puts it, take their own time in coming to fruition. It is as though our thoughts and feelings and moods grow inside us like plants; and that we have to nurture them with an odd mixture of patience and boldness. If these buried or less available parts of ourselves are, as Milner says, seeking expression, then we must want, in some way, to make ourselves known, if only to ourselves, to discover what is growing inside us as we grow. Milner, in other words, sees us as deeply conservative artists – eager for the recognisable object – inclined to be radical; hungry for the new object born out of chaos and uncertainty.

When I was invited to give this lecture I was asked to speak – partly from my experience as a child psychotherapist – on the contribution of the arts to children's mental health; about what the teaching and practising of the arts could uniquely add to this now apparently recognisable object called 'children's mental health'. If this was the Sixties I would probably have been talking about the arts and madness. I think the phrase 'mental health' might be part of the problem I am trying to get at: both a symptom and a sign of the times. In describing the mental heath of a child we are really describing what a good life is for a child; both how we want our children to be, and how come we value these particular things about them: a capacity for life and friendship, say – loyalty, curiosity, courtesy and so. The scientism of the phrase 'mental health' tends to gloss over the moral issues involved. The question 'what is a good life for a child?' – with its implication 'what kind of adults do we want our children to be?' – is necessarily connected to the perennial question, what good are the arts? All definitions of so-called mental health, just like all defences of the arts, are stories

about the kinds of world we would prefer to live in. Like Freud's children with their interesting sexual theories, we are trying to make a world we want: a world we can find ourselves in.

Freud inventing psychoanalysis, children pursuing their sexual theories, or Marion Milner attending to her free drawings are all, one might say, driven by curiosity – a word for which *The Oxford English Dictionary* gives a diverse and revealing set of meanings: 'Carefulness, scrupulousness, accuracy, ingenuity, undue niceness or subtlety. Desire to know or learn . . . inquisitiveness about trifles or other people's affairs. Scientific or artistic interest, connoisseurship . . . a fancy, a whim . . . a vanity, or refinement' and so on. 'Inquisitiveness about trifles or other people's affairs' – with that interesting 'or' – is as good a definition of psychoanalysis, which, for better or for worse, has put the cure back into curiosity. Combining, as these various definitions suggest, the casual and the committed, the scrupulous and the whimsical, egotism and, its opposite, curiosity in some fundamental sense, is what psychoanalysis is about. It is about the roots in childhood of the capacity – the preconditions – for being interested in things and people (what Freud called people's preconditions for loving).

But what psychoanalysis emphasises, as I have said, by giving both childhood and sexuality its due, is that we are, as it were, artists before we are scientists. That is to say, our pre-scientific curiosity is the beginnings, the origin, of what we will come to call our curiosity. Because their curiosity shares the same roots in childhood, the scientist is no more and no less curious, passionate or imaginative than the artist. The scientist, though, has acquired his particular skills later in life. There is, of course, no reason to idealise origins, as psychoanalysis tends to do. Earlier is not necessarily better or deeper or truer. But what we can say from the psychoanalytic point of view is that the arts and sciences – in terms of their styles and methods of curiosity – link us to different times in our lives. Very young children dance, play, act and say very unusual things in words; they don't begin their lives in laboratories. They do their own kind of research, but it is subject to strange

forms of verification. The arts, like the sciences – as conventional practices – have to be learned. But children can learn to finger paint a lot younger than they can learn to use a microscope.

All of this is in a sense obvious. But psychoanalysis tells us a story about why it might matter. About the kinds of versions of ourselves that what we call the arts might tap into. About what, for example, might be happening when we listen to a piece of music that moves us in spite of ourselves. The arts, from a psychoanalytic point of view, have the potential to link us back with what we might call our unofficial selves – that world of tantrums and states of total absorbed attention, that world of very immediate passions; the period in our lives when we were first learning about love and hate, partly by just enduring these extreme states of inner turbulence; and the period of our lives, of course, when we began to notice that there are other people in the world, and that we depend upon them – a realisation of momentous consequences. It is this fundamental turbulence that one can see becomes the stuff of art, and that psychoanalysis has staked out, a bit too costively, as its very own territory: infancy and early childhood, when we first make that transition from our unofficial, relatively uncultured, selves into something more recognisable, something sufficiently acceptable to the family. This drama of acculturation necessarily entails, in Freud's view, the repression, the setting aside one way or another, of all those thoughts and feelings and desires that we can't find or make a place for. It is through art that we remember what we needed to disown, for our survival. We regain contact with the displaced persons in ourselves. We revalue what was once deemed marginal. We are reminded, in the struggle to express ourselves, that the articulate self comes out of the inarticulate self. That once we couldn't speak and now we can; and every time we speak again – and particularly in artistic expression – we traverse this territory again.

'All imaginative writing', Ted Hughes writes in his wonderful book *Poetry in the Making*, 'is to some extent the voice of what is neglected or forbidden, hence its connection with the past in a

nostalgic vein and the future in a revolutionary vein. Hence, too, its connection with the old Adam, with volcanoes, world-endings, monstrous outrages etc'.[4] If all imaginative writing is to some extent the voice of the neglected or the forbidden, then art – both in the making of it, and in the experiencing of it – is always something of an unofficial educator – an acknowledgement of the less recognisable parts of oneself. (It is not incidental that Freud once referred to a psychoanalysis as an 'after education'.) Art is an education, one might say, of what was inevitably left out of one's education. Indeed, one of the most valuable things about the arts in education is that they keep showing children the limits of education. They keep reminding children what is being neglected and forbidden. I don't think there are any great novels, or poems, or paintings, or operas, or ballets that extol the virtues of school: of the official education school can't help but offer.

It is not really surprising that the arts have always been subject to, or raised questions about, censorship. If what we call the arts are ways of speaking about, of dramatising, the neglected or the forbidden or the unacceptable, they are obviously dangerous. By definition, they can pose a threat, and one of the legacies of Romanticism – which psychoanalysis taps into – is the idea of the arts as transgressive. With this comes an assumption about the benefits – the moral value – of transgression, of always adding the unacceptable to the picture (of making the margins central to the text): that what we suffer from is getting rid of or disparaging what belongs to us; that we narrow our horizons, at the cost of our true well-being. The arts, in other words, at their best are an invitation to us to see how complicated we can allow ourselves to be; when politics and religion, at their worst, encourage us to simplify ourselves. When art seems to be a refuge from politics – rather than its inevitable complement – our group (or civic) life is inevitably impoverished.

The unofficial education of art is an education in moral and emotional complexity. It shows us – as psychoanalysis can do, but more variously – that the facts of life are made meaningful, indeed

possible, only by the fantasies of life; that if we lose interest in the neglected and the forbidden we will lose heart; that if our culture does not sustain our children's love of life then it is not worth having.

References
1 Freud, S. (1937) *Analysis Terminable and Interminable*, The Standard Edition of the Complete Psychological Works of Sigmund Freud, London: Hogarth Press and Institute of Psychoanalysis 1953–74.
2 Freud, S. (1908) *On The Sexual Theories of Children,* The Standard Edition of the Complete Psychological Works of Sigmund Freud, London: Hogarth Press and Institute of Psychoanalysis 1953–74.
3 Milner, M. (1957) *On Not Being Able to Paint,* London: New Education Fellowship and Heinemann Educational Books.
4 Hughes, T. (1967) *Poetry in the Making: An Anthology of Poems and Programmes from "Listening and Writing"*, London: Faber.

Replicating reality. Theatre communicates not only through dialogue but also through music, song, dance and mime, which makes it more accessible. The re-enactment of social circumstances and events through drama can help people to find their own solutions to their problems.

WHAT GOES AROUND COMES AROUND: THEATRE AS A VEHICLE FOR SOCIAL DEVELOPMENT AND EMPOWERMENT

CHUCK MIKE

Theatre director and community artist, Nigeria

As a child in the communities in which I grew up there was an expression which was used to explain the process of reciprocity when one individual committed an act affecting another: 'what goes around comes around'. It was often used when one person had acted unpleasantly towards another. On occasions, however, it was also used to express the good that one could experience, should this act by another be carried out in a positive way. In either its positive or its negative state this can be called the law of karma or retribution. In scientific terms one might say 'for every action there is a reaction' and in this particular instance add 'especially with regard to the kind of action that started the process'.

Ours was the simple recognition that what you do will eventually come back to you – in one way or another. Obviously one's start in life has a dominant influence on the type of path one chooses. As a result of this philosophical and communal influence, my vision for the kind of theatre in which I have been most closely involved for the better part of my professional career has been tinted with a positive and wholesome persuasion. Some of the

neighbourhoods in which we lived (in Brooklyn, New York) were quite rough, and fraught with casualties – some arising from gun play and other sorts of violence. I am sure that this, in no small measure, contributed to my choice in terms of what I wanted to 'come around' to me.

First let us examine very specifically the terms which are key to this discussion: 'theatre', 'social development' and 'empowerment'. Although theatre and drama may technically be defined as being different, I will make no distinction between the two.

Theatre, as we know it, may be a composition in prose or verse presented in dialogue or pantomime or dance, a story involving conflict or contrast of character – especially one intended to be acted on the stage or shown on film – or a play.

Social quite simply refers to living together, pertaining to human society, its classes and individual inter-relationships within a population – a community.

Development means to grow or evolve to a more complete, complex or desirable state.

Empowerment denotes giving official power to, authorisation or sanctioning.

I will expound the view that enlightenment, that act of giving intellectual or spiritual light to, instructing, imparting knowledge, teaching or informing, is cardinal to the role of theatre as a vehicle for social development and empowerment.[1] Theatre or drama, because it is an enacted art, informed by an idea, a theme or some set of circumstances or situations, is a medium of expression generally meant for an audience, a 'public' or society to whom it speaks. In this respect, drama may be seen as a form of presentation.

At this point we may want to ask why drama is presented. The more common and obvious reasons involve entertainment, providing some leisure, some escapism from the day-to-day drudgery of human existence. One argument we put forward in our marketing strategies when looking for corporate support for our drama activities has been that it relieves stress. There is no boss to pressure you for the weekly report, no wife to harass you about

the next school fees or the need for a dress for the upcoming wedding, no husband or child or extended family member or nuisance friend to intrude upon the one and a half hours or more of pure unadulterated fantasy you experience. There are, however, other uses of drama.

Because it has (or should have) the power to arrest eyes and ears, drama possesses the ability to influence or, at the very least, to enable viewers to think about the issues it places before them. Drama therefore moves beyond presentational value and functions as a mode of communication and as a thought-provoking medium. When drama is recognised as a communication device and as a method of information dissemination and is conceived with the purpose of perpetuating a particular idea or a set of ideas, it fulfils a specific function for public enlightenment. In other words, the role of drama as a social informant is to deliver (or 'send around', as it were) the message or messages of its originators in the hope of influencing the audience to come around to their point of view and to act positively upon it.

This is not a new concept. Drama as a tool for building awareness has been used worldwide with various themes from the Ancient Greeks to the Alarinjo travelling theatre amongst the Yorubas of West Africa to contemporary urban street theatre. While there are various forms of theatre which have emerged with a view to provoking thought about change, most have been grouped under the term 'avant-garde'. I should like to place them into two basic categories: formal and informal. Both have as indices of the avant-garde school of thought experimentation to their credit but vary in presentation. In my references to the formal I shall be discussing that genre in which the theatregoer visits the theatre for the performance. My observation on the informal will be concerned with situations in which the theatre goes to the audience. Each has its own merit in terms of results – immediate and long term, to which I shall also make reference.

Generally, playwrights have propagated various ideologies through formal dramatic presentations. In Europe, Bertolt Brecht,

in the early 1900s, was perhaps the most noted of these, perpetuating Marxism through his works.[2] The middle part of this century witnessed John Osborne's assault on contemporary middle-class British mores in *Look Back in Anger* and, a few years later, in South Africa, Athol Fugard defied racial segregation for the first time in *Blood Knot*. The mid 1960s found America's Imamu Baraka (at that time Leroi Jones) wielding the sword of Black nationalism. We are told that at one performance *Slave Ships*, one of his most poignant works, moved its viewers to stampede from the theatre into street riots (thus representing at once a violent and immediate act of reciprocity through theatre – but not necessarily the most constructive one). In Nigeria, Hubert Ogunde's *Hunger and Strike* evoked the wrath of Government so much as to shut it down – indicating another unexpected act, the value of which may have been negative for the actors but positive in terms of popular recognition of the facts. Wole Soyinka, borrowing a leaf from Brecht's *Threepenny Opera*, indicted Nigeria's 'petro naira'[3] value system (petrol being Nigeria's main income generator and the nairo its currency) in 1977 with *Opera Wonyosi*. One female viewer commented that she would be ashamed to wear the excessively expensive Wonyosi lace cloth after viewing the production in Ife from which it took its name.[4]

These examples are typical of individual attempts to influence audiences into a particular way of thought, most with a view to arousing, from the outset, some measure of behavioural change in the onlooker. This is often not the only motive. Some organisations, particularly in the areas of safety, the environment and health, offer well-packaged programmes in which drama acts as the pivotal method of expression. In Nigeria SISTERHELP (Synergising Information Systems Towards Enhancing Reproductive Health and the Eradication of Legate Practices) focused on the issue of Female Genital Mutilation (FGM), and used theatre as its method of persuasion.

In November of 1995 an 'Information Blitz' was held in which a debate, lectures and talks were employed for awareness-building

on FGM. A full-length formal play on the issue was presented as the finale of this week-long exercise. The piece had been under research for almost a year and had, as its structure, interviews with interventionists, perpetrators and victims. Its major objective was to get women to talk about an issue which was largely unmentionable, in the belief that a dialogue amongst them would begin the process of change. An unexpected event in the course of these activities was the dramatic change of heart of a perpetrator moments after watching the performance.

Generally the playwright has been the moving force behind these types of motivational formal drama. Some writers and directors use actors to shape the text in the process of rehearsals. For instance, in the course of writing, participants may improvise around dialogue and ideas to mould the piece for publication. Now, the era of the director in the theatre has brought about significant changes. A company or cast may evolve, devise or improvise a text and further writing may or may not be undertaken. It is important to understand this process as it leads us closer to an appreciation of the relationship between formal and informal methods.

IKPIKO and Other Enquiries after the Fact, a play on FGM, was a project I led with a company with whom I work, The Performance Studio Workshop. The Workshop's major focus is on developmental theatre. Plays are devised in workshop fashion. Production processes begin with research in which all participants are involved. The issues undertaken are improvised through dialogue and physical theatre with a view to developing scenes. These are streamlined or 'panel beaten' for coherence, and thematic and dramatic actuality. The script usually emerges afterwards. Locations and setting are often created by the physical use of the actor's body. Basic costumes upon which fragments are placed establish a variety of characters, and players often perform more than one role. Where different cultures are involved this also assists in designating locale. The underlying advantage of this 'minimalist' motif is swift costume changes. Minimal resources are normally used in this mode of theatre as opposed to more orthodox formal

productions. Collaboration is used for much of the music and dance which comes from various parts of the country.

While this method of production and exploration may seem almost bereft of leadership, it is not. Although the theme may be dictated by social needs, some basic idea or concept for the production is brought in by the director. Sometimes this involves a story-line. A 'musical mantra' or a rhythmic theme is devised specifically for the piece in progress and may also accompany this initial concept. Music is usually played frequently during discussions and other 'unconscious moments' so the cast and crew can be influenced by it. The beat exudes the quality and characteristics of the events before us and the music remains the refrain for the play, a constant reminder of its essence. Where it is obvious that dialogue must be written to create balance in the use of language, the director does this also. Very often, when this happens, it is written for specific players. The creative process, however, is never dogmatic. Where something doesn't work, it is jettisoned and/or replaced. This usually happens as the piece begins to find its own level.

I share the belief that directing (especially collective creations) is a sociological phenomenon where the outcome is dictated by all the variables available at one's disposal. It is affected by the time spent creating the product, the varied and unique attitudes and mores of those involved, the space and its relationship to what defines it, the budget, the intent, and how these factors are balanced. These all influence the end result, if only peripherally. It requires freedom of mind to allow the variables to work. I trust my leadership instinct and the collective will as the only guides upon which all else rests and I believe that, invariably, the piece will emerge of its own free will: what goes around, comes around.

Apart from formal play-making there have been several informal theatre movements geared towards similar ends. Often described as one of the most important documented theatrical works in modern times, *Poetics of the Oppressed*, a series of dramatic exercises and games used in Latin America as part of a national literacy

programme, met with great success. It helped to diminish ignorance and create self-awareness amongst a small community. Similarly, in south-west Nigeria the (now defunct) Orisun Theatre of Ibadan in the 1960s evolved a series of political sketches which its originators felt would be useful in public places and in 'nite clubs' where spectators could appreciate and 'reflect' on the injustices surrounding the government of the day.[5]

A revitalisation of this thinking about public awareness performance traditions later resulted in the Ife Guerilla Theatre Unit[6] during the 1970s. In Zaria's Ahmadu Bello University in Northern Nigeria, The Samaru Projects, a self-actualisation theatre programme which goes into the community, has been incorporated into the school curriculum. Recently a Zambian theatre company, the Maloza popular theatre, has achieved great success by moving from village to village promoting Madzi-a-Mayo ('water of life'), the indigenous name for Oral Rehydration Solution, the first-aid treatment for dysentery, a known killer of children.[7]

It is not simply fortuitous that live drama is gaining increasing ground as a pivotal mechanism for information dissemination and education, particularly in Africa. Theatre is an integral part of social life in Africa. This is seen in Nigeria, where some dramatic development seems to have occurred before a piece of meat is bought in the market. The bartering which one can also find in local marketplaces, much like that of the Jews on the lower East Side of New York, lends itself to the heights of dramatic eloquence before customer and seller agree to the price of purchase. (Other instances may be found on Nigerian roads, as in Italy where, in the fever of traffic jams, two motorists exchange abuses only to exchange pleasantries when meeting at a subsequent headlight after the traffic has subsided.) Whether to ratify man's relationship with nature, celebrate the dead, satirise foreign intrusion or castigate its own leadership, drama in Africa has traditionally been multi-purpose and functional, combining instruction, enlightenment and entertainment.[8] My own experiences within this realm reveal specific attributes of theatre which enhance its ability to

communicate themes, and this explains the role it plays in public enlightenment in Africa.

The aesthetic sensibilities of drama give it comprehensive possibilities for use. Theatre is a language in itself, speaking in several tongues: music, song, dance, mime and dialogue. Consequently, it cuts across multi-ethnic/linguistic barriers, communicating in ways which particular dialogue cannot do. It can also turn itself into a celebratory event reminiscent of festival and ritual – recognisable and intrinsic elements of African social life. This powerfully reinforces its message.

The portability of live theatre (especially agit-prop or guerilla theatre) allows it to reach the mass of people who do not have electronics (or electricity), those who cannot read or have no access or knowledge of developmental issues or facilities. Live theatre is more accessible to people who are illiterate, disadvantaged and rural dwellers.

The alterability of live theatre performances enables it to modulate and adjust instantaneously to the requirements of its immediate environment for accurate and maximum communication.

The interpersonal nature of live theatre has several advantages. It facilitates an intimate rapport between communicator and audience, a pivotal factor in successful information dissemination. Interpersonal communication is ideal for African society where a high value is placed on human interaction as opposed to electronics or printed material. A more lasting effect is created because of the human efforts involved. On-the-spot feedback may also be possible, unobtainable through TV, radio or print. Thus vital data may be retrieved which can improve communications and the quality of life of the people.

As a communicative device, a media instrument, drama may provide information hitherto unknown to its audience, enhance and bring light to what they already know and clarify their misunderstandings on the spot.

Amongst the emerging genre of theatre for development

practitioners, there exists a dichotomy between two specific forms of informal theatre which go out to meet the people. The first is referred to as 'Outside In' (migrant, guerilla or agit-prop theatre); the second is referred to as 'Inside Out' or 'Homestead'. The processes involved in these two forms are germane to our understanding of the objectives in terms of social development and empowerment. Outside In performance is mainly concerned with packaging a performance for its intended audience. This is based on a generally accepted and 'prescribed' need (such as AIDS or FGM) as it has been thematically understood by the artists or sponsors. The need may be international or local. There is usually some measure of 'preventative' or 'developmental' intent. Inside Out theatre seeks to use drama *with* the people in a bid to unearth what 'felt' and/or 'real' needs exist amongst the would-be community collaborators. This type of theatre is aimed towards self-development and utilises the culture or cultures at hand. At their finest, both methods employ (or should employ) information-gathering mechanisms. These ferment the knowledge of socio-cultural, economic and political givens associated with the target community in order to effect appropriate strategies. The two also attempt to engage audience participation in the performances and to use improvisation as a means of theatrical structure. The participants are the initiators, together with base groups and others who work 'on the ground' such as local government representatives and opinion-makers. People who, by virtue of being in the community, can have an effect on its progress.

The major distinctions between Outside In and Inside Out theatre, however, are that participants of the Outside In persuasion prepare dramatic material in isolation and perform, engage discourse and leave. Proponents of the Inside Out method live in the community for a brief period and as a result of continued daily interaction with the people, collaborate (or should where possible) with them on the dramatic composition. Outside In activity has been more associated with 'communicating issues' and 'prompting behavioural change'. The Inside Out method has been more

oriented towards initiating action among its participants towards tangible community development. Because its participants live within the community, sociological investigation as opposed to research becomes more feasible. The distinction being made here is about the measure of the time, quality and depth spent on the act of enquiry. Follow-up activity after both approaches is needed to assess the impact of projects.

At this stage, it may be of interest to ask where does enlightenment end and social development and empowerment begin? How do we attain results? What are some of the tangible examples?

I have noted the reactions of the public to dramatic devices such as Barakas's *Slave Ships*, Soyinka's *Wonyosi*, and *IKPIKO*, our play on FGM. The Zambian and South American experiments suggest development in social life in the areas of literacy and also health. Specific and more immediate examples may be gathered from Nigeria's Federal Road Safety experiments with drama in accident reduction and some of The Performance Studio Workshop's community theatre activity in the areas of health and education in Lagos. The Federal Road Safety Commission has not only utilised drama as a functional element of its public enlightenment but has done so exhaustively in all its ramifications – live drama as well as television and radio. In 1988 the Commission commissioned its first sketch, *Babatunde You Are Very Great*, which was used to train the first set of road marshals. The sketch was then used for motor park performances in several states in the Federation. Since that time, nearly 100 or more sketches have been created by various individuals and groups on the varied themes of road safety.

Drama functions most effectively when the mode of presentation chosen is appropriate. This is largely determined by who is going to use it and for what purpose. The Federal Road Safety Commission preference has been for live theatre performance of the Outside In phenomenon, particularly that of the Guerilla Theatre. This is not surprising when one considers the paramilitary nature of the organisation. Deriving its nomenclature

from warfare, guerilla theatre exemplifies certain features which should appeal to any organisation utilising drama consistently. Its primary asset is cost-effectiveness. Unlike formal play presentation, it needs no cumbersome sets, utilises few properties or objects, is mobile and often concentrates on multiple role-playing, and therefore needs fewer players to perform. Guerilla Theatre units were used by the Federal Road Safety Commission (FRSC) primarily for workshops. Apart from communicating new ideas, the units served to enhance, reinforce, and illustrate material. They also functioned as a complement to technical lectures which are enlivened by the units' warfare features: a surprise attack of public enlightenment-packed entertainment!

While we do not have the precise statistics of accident reduction as a result of the FRSC's workshops, we are aware that in 1994, accident reduction had been tallied at over 65 per cent compared to six years earlier. The reduction was found largely amongst inter-state transporters and commuters who plied the national highways. The drama unit at FRSC is now defunct and we are informed that accident rates are back on the rise. I am inclined to believe that drama contributed in no small measure to the positive turnabout of human wastage on our roads. It was, therefore, a significant contribution to the larger social development of our nation.

In 1993 another Lagos-based drama company which specialises in addressing social issues was invited by the United States Agency for International Development and Ministry of Health to devise material which would address immunisation amongst a target audience of women of childbearing age in the Ojo local government area. Research into community knowledge, attitudes and practices on healthcare was undertaken. This was done with a view to introducing immunisation in the area. A short playlet was created which highlighted the detrimental effects of not being immunised. The drama *Tetanus and His Brothers* was devised to encourage viewers to understand the need to be immunised and to get them to seek local healthcare during pregnancy. A guerilla theatre troupe was unleashed into the community with drummers

and performers wearing assorted costumes fashioned into diseases. Audiences were attracted through the 'Pied Piper' effect.

Accompanying the players were health workers armed with vaccines and medical officials who also addressed the audiences, post performance, on the needs for immunisation and healthcare. While the playlet was enacted, queues had been formed to immunise those who had come to see the play. Previous statistics had indicated that during the entire preceding year there were 10,000 immunisations in the target environment. Within a period of eight days with the drama team there were over 6,000 immunisations. The number of phials which had been used on both occasions had been taken as the determining factor for the project's success. Statistics had also been taken at the local healthcare centres to determine community attendance before and after the drama presentation. There had been remarkable improvements in attendance. Audience surveys also indicated that the people preferred the medium of drama to other forms of communication previously employed to the same ends. These were the tangible indicators of theatre's power in determining social development.

However, people are often beset by other problems and this can mean that they are unable to respond in the way which donors or concerned developmentalists feel they should. This attitude – the 'top down' syndrome of information communication (with a view to development) – has recently met with queries about the validity of such efforts. Issues of empowerment are called into question. How do we know what the real problems are for people when there is only a one-way traffic of intent based upon scant knowledge of the problems?

A colleague in the Nigerian Popular Theatre Alliance told of a relevant experience he had with a South American experiment. In the early 1980s, a group of developmentalists was working in a small, densely populated community in Peru which had been earmarked as 'deprived and suffering', largely due to diseases which were thought to be derived from lack of water. The village was situated at the bottom of a hill. Every day the community members

had to walk some considerable distance uphill to fetch water. The donor agency had decided that piping water to these people would alleviate their hardship and they proceeded to construct piping which would bring water down into the village. Shortly after the inhabitants (in particular the men) embarked on a rampage and destroyed every bit of the piping which had been installed. Naturally the donors were at a loss to know why their well-meaning gesture could possibly have been so unappreciated. After all, they knew what the people's problems were and had done what they felt was best for them. A closer examination of the community would have revealed that the young people in particular were often those despatched to retrieve water. The living conditions of the villagers were so congested that the husbands and wives had little privacy and were therefore quite comfortable with the daily absence of the children – so while they were away the parents had time to play!

The real problem, therefore, was housing. Had those involved known more about the peculiar circumstances of the village they had hoped to aid, a more profitable venture could have been initiated to improve the housing of the inhabitants. Certainly it would have been sensible to involve the community more deeply in the process of solving their own problems.

In order to create an atmosphere in which theatre can be a developmental and empowering agent, practitioners have realised the need to live with the communities they wish to assist and by doing so finding out what the community can do to unravel their own problems.

I participated in another Inside Out experiment recently in a remote village by the name of Oluwole. There were the usual bad roads, lack of available drinking water and electricity. These are always major problems in our rural communities. Within a five-day period several other problems, unique to this community, appeared: power struggles, religion and lack of communal effort to solve problems came to light. These were coupled with a few misplaced priorities. After a further five-day period in which the

company worked with the people at their various tasks and spent evening time doing song and dance with the children, plays were developed through improvisation with the community. These highlighted many of the problems which had been unearthed. Decisions were taken upon our departure by various community members from near and far to work together, pool money for technical needs, and use local labour temporarily to improve the roads. Bad roads were a major obstacle to selling their primary product: palm oil. The people we had invited from the local government to attend the final celebration also made promises of assistance. Before our departure they had started building latrines as there were no toilet facilities.

What was it that went around in this community so that it came around to developmental action? By living with them we were able to find out more about them. As a group we could share information after a day's work and discern all the untold contradictions, and celebrate these in dramatic material which would make people react. In a forum we could therefore find solutions in a way that made palatable and conclusive theatre.

Of more interest were our findings when we followed up six months later. The community had kept all their commitments. A pool of money had been saved towards a palm nut milling machine. They had used the husk from the palm nut to patch their roads. Construction on the latrines had been at a halt due to the rains but they had gathered more materials to build than they had had before. The local government authorities, however, had not kept their promises but the people, and in particular their leader, seemed unaffected by this. They had been empowered and lent voices of encouragement to those villagers involved in our next experiment in a nearby community. This showed us how effective the use of progressive local leadership could be in galvanising others in their locality to seek development for their own communities. The chances of sustainability are therefore increased. Individuals become the catalysts for sustainability.

People do not believe that a performance, formal or otherwise,

can solve issues of significance and prompt an immediate change of thought or action amongst the audience. But it is that simple. Some methods simply yield more fulfilling results than others. We are in the business of change. By the nature of the medium we have chosen we are privileged to witness the power of theatre for the betterment of humanity at large.

What becomes clearer to us in our endeavours towards engineering social development and empowerment through theatre is that having a commitment to the use of our art for development and ensuring excellence in execution is vital. Excellence is not necessarily determined by the quality of performance but in the nature of outcomes and in the many ways that the procedure is brought about. If an experiment doesn't work it does not mean that it is a failure. Our try may have been the only one. Once you believe in a product so will others. When you perform well others will follow. What goes around comes around. If theatre is to realise its potential in the developmental arena, those who generate the activity must, like all other professions, hold these truths as self-evident. Because of its participatory nature, the success of this kind of theatre cannot hinge on one individual and his or her presence. There are no stars on the developmental stage. It is a collective activity which requires the input, intellect and creative initiative of all involved. This seems to me an appropriate disposition for those involved in theatre as a vehicle for social development and empowerment.

References
1 Random House (1975) *Random House College Dictionary Revised Edition*, New York: Random House Inc.

2 See: Brustein, R. (1964) *Theatre of Revolt*, Boston: Little, Brown and Company Inc.

3 Ogunbiyi, Y. *Nigeria Magazine*, Nos. 128-129, 1979, P.M.B. 12524, Lagos: Department of Culture, Federal Ministry of Social Development, Youth, Sports and Culture, p. 2.

4 Mike C., 'Soyinka as Director', Interview with Wole Soyinka, *Ife Monographs on Literature and Criticism*, 4th series, No 4, 1986, Department of Literature in English, Ife, Nigeria: University of Ife, p. 45.

5 See: Soyinka W. (with Orisun Theatre) (1967) *Before the Blackout*, Introductory Notes, P.M.B. 3079, Ibadan, Nigeria: Orisun Acting Editions.

6 See: Yerimah, A. (1987) 'The Guerilla Theatre as a Tool for National Re-awakening: a study of the Soyinka Experiments', paper presented at the 7th International Conference of Literature at the University of Calabar, Nigeria May 5-9, 1987.

7 White, K., *Front Lines* Zambian newspaper April 1990.

8 It is interesting to note that a recent trend in Western public enlightenment endeavours focuses on entertainment: 'entereducate'. The theory posed by John Hopkins University in America dictates that people learn better if they are entertained. The rationalisation is that entertainment educates because it is pervasive, popular, personal, and profitable.

Tract (from Boost to Wham) by Richard Wentworth, 1993

MAKING THE ARTS MATTER

PENNY EGAN

Director Designate, RSA

and

RICK ROGERS

Member of the RSA Arts Advisory Group

The RSA believes that the arts have a value and importance to society as a whole and to business and industry in particular. This lecture series began the RSA's advocacy programme to promote the view that the arts influence and enhance every aspect of our lives. At the heart of this advocacy is the ambition to see the arts achieve equal status in the school curriculum with maths and science, and attract the resources to ensure teaching of quality.

Little research has been done in the UK on the effects of arts education and the way the arts are made available and taught. The numerous, valuable evaluations of individual arts projects and initiatives in schools have tended to focus on processes rather than outcomes. They have rarely examined the cumulative impact of involvement in arts education.

In order to address this largely neglected area, the RSA has set up a three-year research project with the National Foundation for Educational Research (NFER) to look in depth at the effects and effectiveness of a good education in the arts, and to document the range of effects and outcomes, intended and unintended, attributable to school-based arts education. The project examines

the relationship between these effects and the key factors and processes associated with arts provision in schools, and the schools' expressed aims and values.

Recognising the extrinsic benefits of an arts education, the project also examines links between pupils' participation in the arts and their general academic achievement – thereby contributing to the growing number of studies in other countries that are exploring the wider gains in learning that can accrue from experience in arts education. For example, in Switzerland and Germany, research is investigating the effects of music lessons on the development of language and social skills.

The intention of the RSA's research is to illuminate good practice and quality educational experiences in the arts through in-depth case studies of five secondary schools with a high reputation for arts education. It is also looking at the extent to which high levels of institutional involvement in the arts correlate with the qualities associated with successful school improvement and effectiveness.

Also on the RSA's agenda is its Redefining Work project, which is investigating the impact of new patterns of work on the way we live our lives. The project's starting-point is that the very nature of work is changing, and that the skills and competences needed in the future workplace are those involving the imagination, creativity, confident communication, self-assessment, teamworking, and lateral thinking: skills more likely to be developed through the arts than through other subjects.

A pilot report, *Work, Creativity and the Arts*, published by the RSA in March 1997, examined the connections between the world of business and the professional arts, and whether bringing the arts into the workplace can help to develop those skills that business increasingly recognises it needs. The RSA is to incorporate this work into the mainstream of its Manufacturing and Commerce programme, which is exploring the leadership of the continuously creative enterprise, and encouraging business schools to experiment with using the expressive arts in their courses.

Another RSA initiative concerns the arts in initial teacher training. There is growing evidence that teachers are ill-equipped to teach the challenging National Curriculum in the arts, especially in primary schools. Training courses for non-specialist teachers devote too little time to the arts. The RSA has initiated a review of the current state of the arts in teacher training and development, particularly for primary school teachers, and will make recommendations to improve and enhance trainees' experience of the arts. A report is being published and the results fed into the Teacher Training Agency's consultation on the training curriculum and standards for new teachers.

The RSA's recommendations in its report *Guaranteeing an Entitlement to the Arts in Schools*, published in 1995, clearly had an effect on government policy, having been taken up and supported by the Department of National Heritage in its arts policy document *Setting the Scene* (July 1996). One of the document's proposals was the setting up of a new national forum for the arts. As the RSA was already seeking to involve its Fellows in The Arts Matter programme, a joint DNH/RSA venture of national forum and regional focus groups was established as part of a flexible and influential network to advocate for the arts within a broad economic and social context. RSA chairman Prue Leith and the then Secretary of State for National Heritage, Virginia Bottomley, co-chaired two meetings of the National Arts Forum in November 1996 and March 1997. Participants identified wide-ranging priorities for action, best summed up as the need to 'create a bridge between those with a passion for the arts and those who have the power'.

The regional focus groups have been based in Birmingham, Bristol and Halifax, and the RSA is encouraging them to continue to meet, building on what Prue Leith identified as 'the RSA's talent for making links and achieving consensus'. They focus on common concerns about, and trends in, the arts. However, each group has also highlighted different key elements of the arts debate. For example:

- encouraging creativity in education, and deciding whether a school arts curriculum should concentrate on framing and putting questions or imparting a body of knowledge that might be called 'the national heritage';
- setting the arts in a wider canvas by devising a mutual agenda between the arts and business, influencing the attitudes of the business leaders of the future, and promoting the arts as a partner in such business-led schemes as urban regeneration;
- advocating for the arts by sharing the practice and inspiration underpinning the best arts activities;
- exploiting the power of involvement: of creators with their audiences, readers and viewers; of families and communities with children through arts activities; of volunteers and business people with schools; and of business with arts and educational organisations through RSA initiatives.

Overall, the groups' discussions have ranged across four main themes:

- the arts and schools;
- the arts and business;
- developing structures for the arts;
- what the RSA can do.

The arts and schools

A major concern is the need to improve arts provision in schools. This should happen from children's earliest years, drawing in parents and local communities to help build a lifelong interest in the arts.

The enthusiasm for and inspiration in the arts that children have developed through their nursery and primary schooling should not be lost in secondary school – nor remain only among those who specialise in the arts. This means targeting more resources into the arts and encouraging all teachers to see the arts as a way of teaching other subjects.

Involving artists in working with children and young people is a

crucial element here. This has to be achieved in a more systematic and coherent way than it is now, and must include more and better training opportunities for working in educational settings.

There are many examples of the passion of one teacher creating a thriving arts environment in a school, and of commitment and enthusiasm of whole communities driving local arts projects. The challenge is to sustain and expand such work over the long term, and extend it to other schools and communities.

The most effective way to improve arts provision in schools is by increasing teachers' arts experience during initial training and continuing professional development. Most primary teachers, for example, are not specialists and often lack confidence in the arts. They need help to pass on inspiration, creativity and imagination through involvement in and enjoyment of the arts; to identify the skills in learning that the arts can bring to education as a whole; and to assess how they can be used every day.

What happens to young people once they leave school is as important as their experiences during formal education. There is concern about many young people's diminishing interest in or contact with the arts, and awareness that their lives can be transformed by qualitative arts experiences. A key question, though, is how best to reach young people so they respond to approaches to provide for their arts needs.

The arts and business

We must look at the links the arts have with the rest of society, in particular manufacturing and business. It is important not to separate the arts from the rest of life. While the arts can do all sorts of things and embrace all sorts of people, they often have to prove some sort of economic argument to be taken seriously.

Arguments for the arts should be widely disseminated, breaking down barriers and ensuring the arts are taken into account at a high political level. The media can play a significant role in this, helping to dispel ignorance about the arts. In particular, business people with an active commitment to the arts should be persuaded to

'put the case' through the media. The 'fire-power' of the RSA Fellowship can help to develop networks and broaden the debate.

The arts should build political awareness and an advocacy base by involving business people in such groups as these and by looking for opportunities to create links between the arts and business, and to unite their agendas.

Some argue that the challenge lies not so much with the more arts-aware senior managers as the younger middle manager who can be hostile or indifferent to the value of the arts to business. Senior managers who do value the arts should turn their passion into advocacy and see that passion as part of their business thinking and drive.

The arts, therefore, can have a growing influence on the future of work. The skills and perceptions acquired through involvement in the arts can help people take greater charge of their lives as changes in work require them to become more like entrepreneurs than employees. These skills are applicable to more than just jobs in the arts, being as valuable in science and technology

Developing structures

Initiatives to set up regional and local structures in order to make things happen in the arts are essential. However, they must work within the context of constraints in funding and the increasing pressure on arts organisations and educational institutions. They can be hindered by a lack of partnership between institutions and groups, and by the need to compete for the same limited resources.

The need to cross boundaries to make effective partnerships for the arts runs right through society – from large business corporations to small communities. More opportunities must be created for collaboration and outreach work, especially in deprived neighbourhoods; closer links must be forged between schools and local companies to develop mutual benefits; an audit of resource structures must be carried out at local level; and initiatives to encourage debate about and action on the arts at grassroots level must be set in motion.

What the RSA can do

The RSA will continue to be an engine for an imaginatively conceived and comprehensive advocacy programme for the arts, encouraging business to become partners in the programme and ensuring the arts have a central role in all other RSA initiatives.

The national forum highlighted nine Priorities for Action:

- Raise the status of the arts in schools, including measures to: enhance the relationship between artists and schools; sustain instrumental music teaching and regional ensembles; facilitate more cultural exchanges for young people with an emphasis on the arts; consider pre-professional training in the arts.
- Keep in touch with young people's needs and aspirations, and address the problem of losing people from the arts in their middle years.
- Take practical measures to increase access to and participation in the arts and to sustain the achievements made.
- Consider the links between the arts and urban and rural regeneration and community development; also those between sectors, for example artists working in the health services.
- Look at the role of the arts in: unlocking creativity in individuals and organisations; promoting lifelong learning; building individual self-esteem; redefining work; and developing the workforce of the twenty-first century.
- Encourage business to develop a new relationship with the arts.
- Differentiate between expressing oneself through the arts and what the arts can teach us, highlighting how the arts are valuable in themselves – intrinsic not just functional.
- Develop strategies which enable people to be more hands-on, rather than just spectators.
- Create a bridge between those with a passion for the arts and those who have the power.

At regional level 20 Priorities for Action have been identified:

- Increase the arts experience of young children and their parents.
- Involve families and local communities more in arts activities.
- Provide teachers with more opportunities for arts experiences both in initial training and professional development.
- Provide more training opportunities for artists to work with schools and the community.
- Assess the National Curriculum's impact on the arts in school and how it can be revised to provide a better deal for the arts.
- Review the structure and influence of 'A' Levels in determining what happens to young people in school and beyond.
- Encourage volunteering to support arts activities in schools and to create an environment in which the arts can flourish.
- Promote greater contact between schools, business and industry.
- Provide more support for young people when they leave school to enable them to pursue the arts.
- Increase participation in the arts and advocate for its central role in business and in society as a whole.
- Tackle inequalities in arts provision and increase access to the arts for deprived groups.
- Spell out the values and qualities of the arts in relation to themselves and to other areas, such as business and industry.
- Explore the relationship of the arts to the future development of employment and of entrepreneurs.
- Promote the arts as an essential part of the jigsaw of urban development and social renewal.
- Identify what art is and the new art forms being developed, and broaden the definition of what counts as creative.
- Encourage risk in the arts, by those who practise them and those who fund them.
- Find out the needs of consumers of the arts as well as those of creators, by seeking their views and perceptions, and assessing what they want locally.

- Build bridges of understanding and co-operation between different perceptions of and attitudes to the arts and creativity — be they linked to age, education, social or economic situation, or art form.
- Develop imaginative and structured regional and local approaches to lobbying, advocacy and mentoring.
- Explore how best to lobby for the arts, especially through the media.

The RSA is committed to working with others to take forward this agenda. If you are interested in finding out more about The Arts Matter programme, please contact Emma Hill at the RSA address or telephone number given at the front of this book.

INDEX